EW 100:
Centennial Essays
in Honor of
Edward Weston

COVER:
Edward Weston,
Shell (13S), 1927.

EW:100

Edited by
PETER C. BUNNELL
DAVID FEATHERSTONE
Contributors
ROBERT ADAMS
AMY CONGER
ANDY GRUNDBERG
THERESE THAU HEYMAN
ESTELLE JUSSIM
ALAN TRACHTENBERG
PAUL VANDERBILT
MIKE WEAVER
CHARIS WILSON

Centennial Essays
in Honor of Edward Weston

UNTITLED 41
The Friends of Photography
Carmel, California

ISSN 0163-7916; ISBN 0-933286-44-9
Library of Congress Catalogue No. 86-80460

UNTITLED 41
This special double issue of *Untitled* is the forty-first in a series of publications on serious photography by The Friends of Photography. Some previous issues are still available. For a list of these write to Post Office Box 500, Carmel, California 93921.

*Picture
Credits*

Contents

Acknowledgements

IT IS MOST APPROPRIATE THAT THE FRIENDS OF PHOTOGRAPHY publish this book of essays celebrating the one-hundredth anniversary of the birth of Edward Weston. Weston spent most of the last thirty years of his life in and around the village of Carmel, and made many of his most memorable photographs there. The Friends was founded in that environment less than a decade after the photographer's death. While our publications, exhibitions and workshops over the past nineteen years have explored the full range of photographic expression, the mere fact of our location in Carmel has contributed to a commitment to excellence in photography that has been influenced not so much by Weston's championing of a specific photographic style, but by his unrelenting dedication to photography itself.

There is a further connection that makes it a pleasure to present this special double issue of *Untitled*. The very first volume of the series, released in 1972 and called, simply, *Untitled #1*, was an appreciation of Edward Weston by Dody Weston Thompson. This twenty-four-page issue inaugurated what has become one of the most successful series of photography publications extant. It is thus with a great deal of pride that we bring the *Untitled* series full circle and publish a book of original writings on Edward Weston in this, his centennial year.

As with any book of such scope, its publication would not have been possible without the help and dedication of a great number of people. I would like first to thank the editors, Peter C. Bunnell and David Featherstone, for their commitment to seeing the book through to completion and for their enthusiasm throughout the project. Grateful acknowledgement must also go to the nine contributors, not only for their willingness to share their insights into Edward Weston's life and work, but for their cooperation in meeting our various deadlines over the past year. Thanks must also go to those writers who submitted abstracts for consideration, but whose proposals were not ultimately selected for inclusion. Recognition must be made of the many institutions and individuals who granted permission for us to reproduce the illustrations in the book, and who provided the prints used for reproduction.

On the staff of The Friends of Photography, thanks must go to Desne Border, who combined the many diverse visual and verbal elements of the book into such a pleasing and beautiful design. Thanks also go to Linda Bellon-Fisher, for her editorial assistance; and to Claire Braude,

John Breeden, Lorraine Nardone and Julia Nelson-Gal, for their help in preparing the manuscripts. Thanks also to David Gardner and the staff at Gardner/Fulmer Lithograph for their careful attention to the quality of the reproductions.

JAMES ALINDER
Editor, The *Untitled* Series

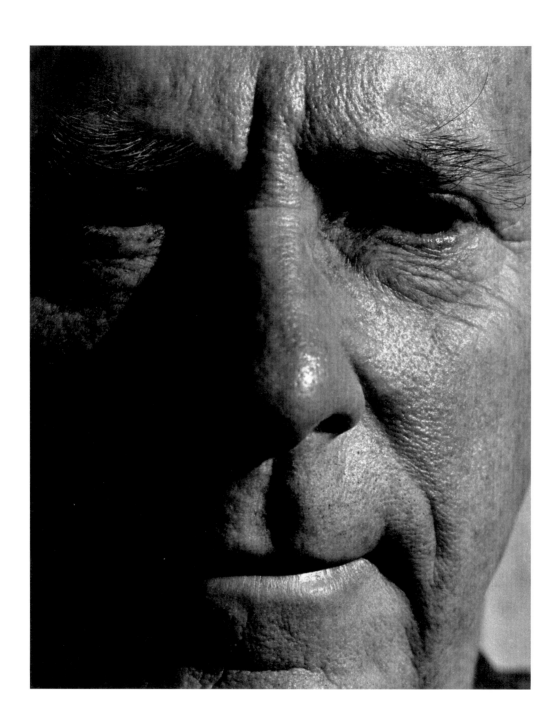

1986 IS THE CENTENNIAL OF EDWARD WESTON'S BIRTH, AND WHILE such a commemorative date may be an artificial point at which to reappraise and even salute an artist's odyssey, it has become tradition. Thus, in this issue of *Untitled*, The Friends of Photography has provided an opportunity for nine writers and scholars to review and reconsider aspects of Weston's career and work. It seems to me that these contributors also offer a tribute to Edward Weston.

This volume is the first commissioned anthology of writings on Edward Weston. Coming as it does soon after the 1984 publication of Beaumont Newhall's and Amy Conger's *Edward Weston Omnibus*, an anthology of selected criticism about Weston which for the most part had been published during his lifetime, this new collection gives the reader an opportunity to consider Weston in what may be termed a current or contemporary sense. That is, all of these pieces were commissioned in 1985 in preparation for this special commemorative number of *Untitled*.

This issue of the publication emerges from a series of invitations the editors sent to a large number of internationally recognized writers asking each of them to submit an abstract for a proposed essay on a subject of their choice relating to Weston's life, work and legacy. From this group some thirty abstracts were received. A number of essays were commissioned, and most of the authors invited to do so did produce finished manuscripts. While the original concept or structure that was envisioned by the editors for this publication has not been carried out exactly—the final form of a book such as this is dependent on the responses of the contributors to the initial call—this selection of nine essays does represent a coherent group that is a reflection of the original plan.

Edward Weston is a seminal figure in photography's history. An artist whose work has influenced countless photographers of varied persuasions, his artistry also stands as a measure for the accomplishment of still others. If Weston's life is not the model of the consummate artist for many, it is at least the partial inspiration for some. His daybooks have become what Delacroix's journal or Van Gogh's letters are for the education of the young; reading them assumes part of the rite of passage. All of these are about the myths, prejudices, worries and observations from which young artists generate their opinions and loyalties, but Weston is more, or greater, than the mere accumulation of

Introduction

BY PETER C. BUNNELL

PLATE I, OPPOSITE:
Morley Baer,
Edward Weston, ca. 1948.

work and memorabilia; he is an ideal. He is that artist in photography whose commitment and singular dedication to the medium causes him to have a symbolic status that extends beyond his tangible accomplishment. Only in the rarest instances does an artist achieve this personal measure of being affectionately considered a true master.

When Weston died in 1958, photography was poised on a kind of fulcrum point in its recognition as an established creative form within the fabric of twentieth-century art. Its modernist authenticity was acknowledged, and any nostalgia for the halcyon era of the century's first three decades was forgotten in the euphoria for photography's accomplishments over the previous twenty-five years. In what may be seen as a curious anomaly, Weston was a critical participant in the first half-century of American photography's pictorial evolution, yet he came too early for—or just before—what we might term the profuse contemporary realization of photography's importance. In retrospect, I think we will see that the date of Weston's death will mark one of those turning points in a medium that signals its progressive evolution.

The end of Weston's career, coming as it did some twelve years after Alfred Stieglitz' death, also binds him in an aesthetic constellation to the earlier master, and the work of these two artists dramatically characterizes both the maturation of the medium and the emergence of its critical force. These two men are the giants of American pictorial photography who, by spanning the pivotal evolution of this form of image making, give evidence of the significant expressive substance of photography. Together they affirmed the notion that personal responsibility is the fundamental quality in the sovereignty of image content, and the twentieth century can be seen to be divided into two periods, the Weston/Stieglitz era and afterward. Each of the writers in this anthology recognizes this hypothesis, either explicitly or implicitly, as they delve into the facts surrounding Weston and his work.

This publication, to summarize its content, proceeds from Robert Adams' essay, in which he focusses on the relation of the artist's biography and his imagery, to Paul Vanderbilt's concluding and affectionate meditation on a single Weston image. In this final piece, Vanderbilt stresses Weston's spiritual and philosophical values, he demonstrates how a work of art can affect a viewer's sensitivity to principles and inspire him in his own search for moral courage.

Because Weston is so fundamentally identified with a single site—

Point Lobos—it was thought essential to give a hint of the background and environment of the central California coast, especially the village of Carmel, at the time he first arrived. Thus Therese Heyman considers this bohemian center during the years after World War I; in doing so she reveals that artists such as Weston are not empty vessels into which the content of culture or place is poured, but that they are as much makers as receivers.

Weston is one of the few photographers who has left so abundant a written record of his thoughts about the medium. In fact, few artists could generate as extensive a publication as my own anthology of his writings (*Edward Weston on Photography*, 1983). Estelle Jussim's careful reading of his vocabulary and usage gives us additional understanding with which to gain greater insight into his meaning and expressive temperament. She recognizes that most artists are confined by the verbal resources available to them, and as a commentator it has been her role to analyze historically what Weston said and how he said it.

In approximate chronological order, I next arranged four studies on aspects of Weston's work: Amy Conger's investigation of the relation between Weston and Tina Modotti, which took place during the very important period of Weston's life spent in Mexico; Mike Weaver's iconographic study of the spiral motif in Weston's photography during his first major California period; Andy Grundberg's analysis of the late landscapes and Alan Trachtenberg's account of Weston's photographs for the Limited Editions Club publication of Walt Whitman's *Leaves of Grass*. This latter text is one of a series by Trachtenberg concerning various important photographically illustrated books of the nineteenth and twentieth centuries. Finally, it was thought essential to include a piece by an individual such as Charis Wilson, who knew Weston intimately and who could reveal out of her experience the specific character of the man and the autonomy of his spirit.

In reviewing the essays, I note some strong linkages or parallels between authors and texts. First, an overtone of religiosity runs throughout. The authors share a distinct desire to see Weston as a moderator of values whose identity and symbolism was recognized and appreciated by his most astute admirers in his own time. They also see that Weston's imagistic rhetoric reveals an inspiration and a context of concerns that goes beyond the essence of modern formalism, and that it gives significance to what he referred to as "the wholeness of life." That

in subject selection his realism was more than that of a mere pragmatist; it was brought forth from the being of an insightful, volitive and genuinely expressive artist who understood that in his act of photographing he was making moral and philosophic choices. These scholarly witnesses testify to these observations as though of one mind, such that I wonder if they do not, therefore, reveal a unifying force in our time that causes us to seek so desperately a resolution to the condition of doubt.

Further, these writers emphasize the pictures as the central signifying elements in our understanding of Weston's photography and engage in the detailed analysis of specific works. While accepting some of Weston's own self-effacing comments, they see in his pictures the evidence not so much of his eye; that is, not the re-presentation of what is seen, but the trace of his heart and mind in the service of his expressive demands. This desire to approach the work in humanistic terms and to consider it without theoretical prejudice is perhaps a reaction to the vacuity of so much contemporary writing by pedantic intellectuals. To interpret the photographs in this traditional manner requires one to know the specific character of the works, the special equivalency of things, and to place oneself back into the realm of creation.

Third, there is the simultaneous and persuasive expression in all these essays of the change and growth in Weston. He is not revealed in a one-dimensional way, but as an evolving and maturing artist of substance whose contradictions are as meaningful as his consistencies. Underlying this belief is another held by all of the writers, the recognition of what I refer to as the concept of responsibility. This is the realization that in the richness of genius will be found the self-centeredness of the artist's knowable struggle with identity. To reject this belief is to see only the life of accommodation and commonality.

Finally, these authors project the sense of what we could call Weston's intellectual wholeness. This, it seems to me, clearly replaces the sometimes narrowly dimensional characterization of Weston that we have had up to now. Robert Adams touches on this notion specifically with his criticism of the currently available biographical work and, for instance, the myopic focus on Weston's love interests. A major thread extends through these essays—that the breadth of Weston's nature and sensibility frees these contemporary writers to challenge past stereotypes and to extend their interpretative investigations into the inner

recesses of Weston's originality. The achievement of his themes determines this intense and insightful approach. No longer can Weston be viewed in so simple and tidy a fashion as had once been the case.

It would be revealing of Weston to know what he would think of this volume created on his behalf. In his later years, his understanding of picture making was so secure that he frequently took offense at those who commented on his work by suggesting that such interpretations only revealed the critic or writer and had little to do with him. But my sense is that, far from ignoring the written commentary on photographers and their work, Weston was actually drawn to these portrayals. His early call for the photographer to be mindful of notices and reviews in his 1913 article "A One-man Studio" established an attitude that was never ignored, even though it increased in sophistication over the years.

A point of awareness was indelibly marked in Weston's mind when he read Paul Rosenfeld's impassioned essay on Stieglitz that appeared in the *Dial* for April 1921. In the introduction to my compilation of Weston's own writings I reviewed this article carefully, and I contend that it was this essay that provided Weston with a pathway for his new work of the twenties and also provided him with his first choice of a critical vocabulary. Throughout the remainder of his life, Weston followed the critical discourse closely, though in all probability his view of the medium's history concluded with himself, as is the usual conception held by most artists. One obvious instance of his participation in a critical dialogue is, of course, the protracted "battle" against William Mortensen and his brand of artificial and theatrical photography. The controversy that surrounded this false but emotional issue in the pages of *Camera Craft* during the thirties, which elicited impassioned comments by Ansel Adams, John Paul Edwards, Willard Van Dyke and others, including Weston, was really something of a storm caught in its own vortex. Their pronouncements must be seen now as a puritanical defense of straight photography, because Mortensen did not represent anything like the mainstream of Pictorialism. Rather, he was a regional phenomenon, an aberration of Hollywood masquerading as a pictorial photographer. The whole episode probably left Weston disillusioned, and this experience may have been one of the reasons for his adopting the pose later on of one who rejects all criticism or commentary. But from his own letters and papers, most of which are now housed at the University of Arizona, we know he was always conversant with the

best writing of his time. I believe that he sought in the opinions of others a ratification of his own work, knowing full well, however, that the fundamental state of artistic creation is not intellectual but cognitive. In the observations of others, he found a way to collaborate his intuition. All arrogance aside, Weston craved this affirmation.

I would like to thank all of the authors of these articles for their new contributions to the Weston literature and for their cooperation in the preparation of this issue of *Untitled*. I would also like to thank those who submitted abstracts for essays and those who considered our initial request for submissions. All of the editorial work has been done by David Featherstone, who, in his expert manner, has brought clarity and a brighter display to each author's writing. He was also my collaborator for the entire project. A special thanks is extended to James Enyeart of the Center for Creative Photography for his cooperation and assistance in securing the reproduction prints of the Edward Weston photographs.

Princeton, New Jersey
February 1986

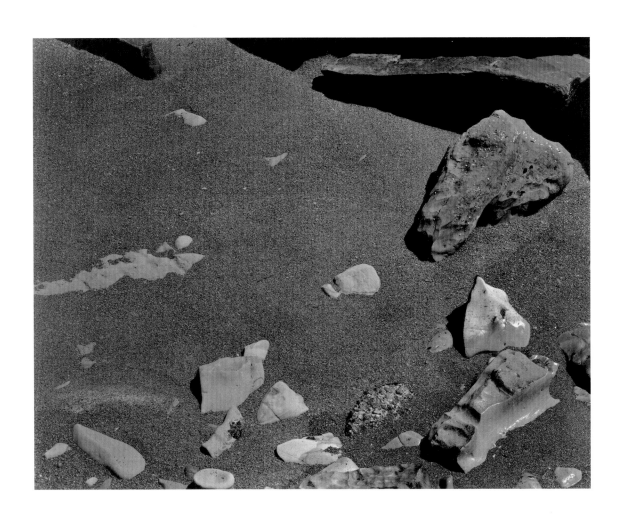

THE ACHIEVEMENT OF EDWARD WESTON:

The Biography I'd Like to Read

BY ROBERT ADAMS

BIOGRAPHY WAS GIVEN ITS BEST DEFENSE BY SAMUEL JOHNSON, who wrote that it ought, along with being interesting, to tell the truth:

If nothing but the bright side of characters should be shown, we should sit down in despondency, and think it utterly impossible to imitate them in anything. The sacred writers . . . related the vicious as well as the virtuous actions of men; which had this moral effect, that it kept mankind from despair.

Biographies thus give us "what we can turn to *use*."[1]

As a subject for biography, an artist requires a particular method of approach, I think, because, as Aristotle observed, the artist is distinguishable from the mentally ill (among whom Freud numbered us all) only by the fact that he manages occasionally, through his art, to escape the sick person's distorting, isolating perspective. It is therefore the artist's *work*, set against the life, that tells us how, in a measure, he escaped failure; thus it is the work that we must study if we are to learn something useful.

All but one of the recent biographies of photographers leave me embarrassed at having listened to things for which there is, on the basis of the books, scant justification to listen. Gossip. Only John Szarkowski and Maria Morris Hambourg's critical biography of Atget (about whose private life, like Shakespeare's, there is helpfully scant information) keeps the work foremost and uses it to illuminate the life, balancing the inevitable compromises in the life with the achievements in the art.[2] Patricia Bosworth, who was denied permission to reproduce Diane Arbus' pictures, apparently felt it was impossible to discuss them, and so presents in her book only the story of a compulsive rich girl who destroyed herself. Milton Meltzer's biography of Dorothea Lange, which is almost as negligent of its subject's work, except when Meltzer quotes others who cared about it, tells chiefly the story of an unsuccessful mother who is self-deceiving. Ben Maddow's biography of Edward Weston, though it contains perceptive remarks about some of the pictures, focuses on Weston's love affairs.[3]

As a practical matter, it seems to me that the biographer of an artist ought not only to begin with a commitment to use the subject's work as primary evidence, but to remember the nature of Aristotle's argument for its centrality—that it is a unique curative for sickness—and assume that art begins in unhappiness. True, the goal of art is to convey a vision of coherence and peace, but the effort to develop that vision starts in the more common experiences of confusion and pain. Which is to say that if

we are to use the artist's work as our evidence about his life, we must, to some degree, turn it around and find the negative that stands behind the positive. If a work shows a beautiful woman or an orderly landscape, the biographer ought to inquire about the nature of the world in which the artist usually felt he lived, the one he struggled to place in a more affirmable perspective.

What I would really like to know from a biography about Edward Weston—I hope a major one will be written someday—is where the greatest pictures came from. I think they did not necessarily come from the sometimes foolish man who was a vegetarian but enjoyed bullfights, the one who believed in astrology and wore a velvet cape. They must have come from a more thoughtful person, one who suffered enough to learn.

MADDOW BEGINS his biography with a description of the room where there are stored the "remains of Edward Weston's mind"—first the "negatives . . . , sample prints, [and] bound portfolios of his work," and second, "family records, boxes of letters, . . . [and] his journals."[4] To these, Maddow says he will add "the memories of those who knew him" in order to "give us a necessary third dimension," encouraging us to believe that the list represents the order of importance in which he holds the evidence. We read many pages into the biography, however, before we come to substantial references to specific pictures, and such references remain scarce throughout the book.

One wonders why biographers, who usually begin their studies out of enthusiasm for their subject's art, so often quickly turn away from the art. The answer seems to be that they do not share enough experience with their subjects, and so are unable to reconstruct the origin of the work. Maddow tries to describe, for example, as if from Weston's perspective, the act of photographing, but the description fails to come to life. He offers few insights into a photographer's particular approach to the world, insights like those Szarkowski, who was a photographer for twenty years, gives us in his discussion of Atget when he notes the special interest to photographers of a few days in spring when leaves are green but not fully out, days that allow a record of both light and structure. Maddow just does not know enough about the act of working with a view camera, for instance, when he concludes that the Guggenheim landscapes in California were seen by Weston as a

motion picture cameraman would see a tracking shot, as "a continuity of experience rather than an intensification."[5] Months of setting an 8×10 camera up and down would probably disabuse him of that interpretation. Put more generally, it seems to me that there are relatively few great biographies of visual artists because great biography is motivated by a kind of constructive envy, and is usually written in the hope of emulating the subject's achievements. A writer, or even a sometime moviemaker like Maddow, is unlikely to envy a still photographer in the way or to the degree that he would envy another in his own profession.

The problem with Maddow's biography is not that he is insensitive to the photographs—he writes briefly but compellingly about the beauty of the shell pictures, for instance.[6] And the book as a whole is not simple; Maddow notes a dark side to Weston, depressions that occurred often, and in puzzling contexts. When Weston's pictures were reviewed enthusiastically in Mexico, for example, Weston is quoted as writing that he "became obsessed—overwhelmed by the desire to quit."[7] This is an experience common to artists, but rarely in that degree. Maddow notes some possibly contributing factors to the depressions—his mother's death when he was five, his sister's extremely high expectations for him and the financial problems that never let up—but none is shown to account for the severity of the depressions, especially when they are linked to the unusual shape of Weston's career, one in which he drastically reinvented himself several times, going from pictorialist to modernist to landscapist. These changes, together with his destruction of many letters and notes, suggest a depth to Weston's struggle that remains unexplained.

IF WE USE Weston's pictures as evidence about the nature of his life, what might the pictures tell us? By way of example—and only that—I would like to look briefly at three truisms about Weston that might be open to modification or better explanation if we put them more firmly in the context of his work.

Consider first the apparently indisputable fact that Weston loved many women. Maddow traces his affairs mainly on the basis of letters and the testimony of friends, but if we add to these the nudes that Weston took concurrently, the impression we have of the quality of the affairs is altered; Maddow alleges that "love and photography was a

combination that was natural to him all his life," and that "the results were effective on all counts,"[8] but the evidence of the pictures contradicts this. With the exception of two full-length nudes of Tina Modotti in Mexico, and five of Charis Wilson on the Oceano dunes (not many, considering the number of nudes Weston took), the pictures that supposedly resulted from Weston's love for his subjects are, relative to the rest of his life's work, unsuccessful; they are cold to the point of being dead—a crucial flaw in pictures of *people*, who are animate—and thus unattractive on any but the most icily aesthetic terms. As Maddow describes them, though he does not himself call them failures, "More and more, his nudes became examples of strict . . . form;"[9] of the ones from the late 1920s and early 1930s he observes, "the compositions are markedly influenced by vegetable and banana forms."[10] Weston himself acknowledged that "I have had a back (before close inspection) taken for a pear."[11]

Kenneth Clark suggested, rightly I think, that pictures of nudes must, to be successful, "arouse in the spectator some vestige of erotic feeling."[12] Weston, for his part, disagreed. And he vehemently, and correctly, denied that his nudes were erotic. Erotic art evidences, however obliquely, a degree of sexual desire by the artist for his subject, and Weston's nudes do not, except for those noted, evidence much desire at all. The limbs and torsos and whole figures are treated as shapes to be enjoyed as one might the sight of a smooth stone.

Presumably Weston defended his nonerotic nudes as successful because he felt that the human body presented, as Clark described it, a problem.

The body is not one of those subjects which can be made into art by direct transcription. . . . Naked figures [do] not move us to empathy, but [to] disillusion and dismay. We do not wish to imitate; we wish to perfect. . . . Photographers of the nude are presumably engaged in this search, . . . and having found a model who pleases them, they are free to pose and light her in conformity with their notions of beauty.[13]

Clark goes on to say that the photographer's effort, which he implies is unlikely to succeed, must be toward achieving "the harmonious simplifications of antiquity," which is done by eliminating the model's "imperfections."

While one can sympathize with a photographer's attempt to confront so unresolvable a problem as eliminating imperfections while not

eliminating life, one must also note that when the effort is carried to an extreme, as it seems to me Weston carried it when he photographed people as if they were botanical, the solution can amount to a human failing, one that presumably should interest a biographer. Especially when the solution is applied, as the daybooks testify and as Maddow notes but does not develop, just before having sex with the model (the reverse being, as Maddow observes, probably the more common order). And especially when it usually involves cropping or turning away the face of the model.[14]

I am not qualified to sort these matters out (Weston was doubtless partly right when he complained that "the only thing critics do is psychoanalyze themselves") but what seems clear on the basis of the pictures is that Weston was inclined to treat the bodies of his lovers as things free of individual personality—an inclination not too different from that of the pornographers, though the results are in some ways dissimilar—and imperfectly related to Weston's statements of affection for his models. When one contrasts the cold pictures he made of them with the picture he took of Jean and Zohma Charlot embracing, one wonders if that portrait, in its eroticism, was not Weston's best insight into what so often eluded him.

It might be argued that the nudes, with their implication of Weston's limitations, show us nothing that the daybooks don't. The nudes, however, unlike the occasionally self-serving notebooks, show the condition as its own judgment. The pictures, by which Weston measured his achievement as an artist, are most of them dull, and I think even Weston must have suspected this at times.[15] But beyond the artistic failure there is the evidence they carry of personal failure. The nudes record not desire, but a sad sort of invention and staring. A biographer who directs our attention to the pictures is saved any need to moralize.

ANOTHER TRUISM we might consider in the context of Weston's pictures is that he was politically withdrawn. As Henri Cartier-Bresson is reported to have complained, "The world is falling to pieces—and Weston [is] . . . doing pictures of rocks!"[16] Weston himself contributed to this overly simple view of himself when he said things like "I have been a [nonpolitical] anarchist since my twenties."[17]

Using other quotations from Weston, however, Maddow establishes that he was not politically thoughtless; he disliked capitalism for its

encouragement of greed, and communism for its abuse of the individual. Nor was he uninvolved in the political events of his day, having participated briefly in the WPA, written letters to newspapers against the internment of Japanese-Americans and served as an airplane spotter during World War II.

Maddow is puzzled, however, by the fact that Weston was especially unhappy around the time of the war:

> . . . *the* astonishing *[my emphasis] fact is that, in the midst of this full and happy and famous year [1940], Weston's photographs were, a good half of them, anyway, quite frankly funereal. Many are studies of cemeteries; . . . even the land-scapes and the houses are dank and decayed. . . . One* speculates *[my emphasis] in what way Edward Weston had become deaf and brooding and fixed upon the eternal.*[18]

I think Maddow's astonishment puzzling. Weston, it seems to me, heard well enough. His sadness may in part reflect the unrecognized but experienced onset of Parkinson's disease, and it must, to some extent, be attributable to the deterioration of his marriage with Charis Wilson, but surely there is also the fact that by 1940 many thoughtful people, among whom there is no justification not to include Weston, believed that a world war had become inevitable. Auden could, after all, write in 1939 that "the clever hopes" of the decade were expiring, and no one found his sadness a cause for mystified speculation. Weston cherished, one remembers, four sons who were of draft age.

What might the pictures bring to the common misapprehension of Weston as apolitical, and to our understanding of Weston's depression at the time of World War II? Maddow is disturbed by the grotesque pictures that Weston made around the house during the war, such as that of Wilson nude except for a gas mask. Common sense suggests, I think, that they expressed an anguish that originated in part from the war, in addition to the fact that the pictures were in certain respects made out of necessity (gas rationing meant no travel, and Point Lobos was occupied by the military), and despite the fact that Weston defended them on the same grounds as his other work. The pictures have no parallel in Weston's other work, they are certainly neither funny nor beautiful, and they are not, as Weston tried to claim, a case of an artistic breakthrough initially misunderstood (at least I know of no one to this day who likes them). It is right that we are disturbed by them; they demonstrate the cost of living in this century.

Of more importance, though, are the pictures he tried to make when opportunity allowed. In 1940, for example, he set out to attempt work, on commission, that would accompany an edition of Whitman's *Leaves of Grass*, to photograph in accord with the most famous of all hymns written in honor of this country. He continued the effort, until America's actual entry into the war forced him to stop, despite the evident fact that, though he traveled long distances, the pictures were less successful than those he took on Point Lobos. A person like that would have to be, I think, one who cares, even if without hope, for his nation.

Beyond that, consider the pictures he made at the close of the war—for instance the one, beautiful and terrible at once, of the pelican floating dead in the tidal wrack, as if carried home from the Pacific conflict. Think too of the pictures he made of his boys out on the rocks, in the celebratory sun. And above all of the picture of Brett and his daughter Erica (1945), she with her doll and he with his hand around her shoulder, both thinking their own thoughts but both depending on each other. Weston's early (1925) picture of Neil on the couch, an aesthetic triumph made at the cost of using his son while the boy suffered from a migraine, would never have been repeated by the time Weston took the one of Brett and Erica. The later picture was taken by a man who, it seems to me, had watched for four years as parents and children had been forcibly separated forever.

A consideration of Weston's political awareness in light of the pictures he made suggests, then, that he responded to social issues with personal concern and ultimately with a renewed commitment to work and to life. Part of this was expressed as a deepened commitment to individuals around him, a change that was itself, at a time when things were already being measured more and more by their mass effect, a political act.

A FINAL TRUISM we might consider with the pictures in mind is one that Maddow repeats from others—that the late photographs made at Point Lobos are comparable "to the last quartets of Beethoven."[19] "This is very apt," Maddow observes, "in the sense of their dark complexity." It is not their complexity, however, but their darkness that seems most important to him: "the black-and-white photographs he took during this time were black indeed; eroded rock on black sand; trees gripping into a black cliff"[20]—all seeming to picture, Maddow suggests, death.

By the end of the biography, in fact, Maddow questions their complexity. He writes that Point Lobos was, before Weston showed it to us, a "confused upheaval," but that it had "a beautiful order imposed upon it by Edward Weston."[21]

Setting aside the question of the degree to which the order Weston showed us was imposed or discovered, I think that in the later pictures at Point Lobos there is less of an obsession for order than in the earlier ones. John Szarkowski has made this point about the relatively late (1937-1938) Guggenheim landscapes as a whole. "The photographer's authority is maintained with a looser, gentler rein. A sense of the rich and open-ended asymmetry of the world enters the works, softening their love of order."[22] In the case of the pictures taken over the years at Point Lobos, this can be noted in a general way in Weston's increased production of long shots, and the inevitable lessening in control over the subject that this involved. The change can also be observed by comparing pictures of relatively similar subjects, as for example the best known shots of rock walls (figures 1 and 2), in which Weston attained freer, subtler composition as the years passed.

The loosening toward complexity is apparent, too, in the development from the earlier pictures of single beach rocks, like the one (figure 3) photographed in 1930—whole, smooth and centered in the frame—to the last picture (plate 2) that Weston made in 1948, with rock fragments, almost shards, scattered at the borders of the frame. Also relevant is Weston's increased willingness to photograph the shifting expanse of the sea itself, and even breaking waves; not since Mexico, when he had recorded animated faces (Galvan shooting, Tina reciting, Guadalupe talking) had he so often accepted into pictures what could not be precisely foreseen or controlled.

The biographical importance of the last pictures seems to me not so much that they show us Weston's awareness of death, but that they demonstrate the personal achievement of Weston's life, the achievement of which Beaumont Newhall wrote after seeing Weston in a late stage of his illness: "He had accepted his fate and was resolved to bear it."[23] The progressively relaxed compositions of his later pictures testify to a willingness to affirm life on other than selective terms. They show the peace that is evident in his last letters to friends, letters as beautiful as any of which I know—brief, colloquial, dignified and urgent with affection.

Running through much of Weston's life was an engaging spirit of

celebration, and that also grows in the late Point Lobos pictures. While I'm not sure I can describe its expression convincingly, I think I see it in the photographs—a new sensitivity to light, to light just in the air, especially to light as it is caught by shooting into the sun. Whereas in most of his work he had used light as it came from behind or to the side of him and fell on objects so as to model their shapes, and whereas in his earlier landscapes the sky tended to be used for the shapes it formed or held—for the horizon line, or the clouds—there are times in the later years when the substance of the sky, occasionally blank, seems to fascinate him almost in itself. Though such a thing is virtually unphotographable, in combination with his interest in trees and rocks and land forms it begins to result in views that are newly radiant and that, as never before, invite entry. I think, for instance, of *Cypress Grove, 1938*, (figure 4), with its ragged trees in thick, luminous, coastal air. What an extraordinary day.

FIGURE 3:
Edward Weston,
Eroded Rock, 1930.

FIGURE 4:
Edward Weston,
Cypress Grove, 1938.

IF, THEN, we are led eventually by a full-scale biography to combine what we might learn from Weston's pictures about, among other things, the three truisms—that he was a prodigious lover, that he was apolitical and that his final landscapes are especially significant—might we not see more clearly the nature of Weston's achievement? As remarkable as was his creation of the pictures—and perhaps to some degree through that—he appears to have become, after many failed attempts, another person, growing away from his earlier egoism and its disappointments toward a more generous view of other people and of the world as a whole.

NOTES

1. James Boswell, *Life of Johnson*, vol. IV, Birkbeck Hill ed. (Oxford, 1950), 53.

2. John Szarkowski and Maria Morris Hambourg, *The Work of Atget* (New York: Museum of Modern Art, 1981-85).

3. Patricia Bosworth, *Diane Arbus: A Biography* (New York: Knopf, 1984); Milton Meltzer, *Dorothea Lange: A Photographer's Life* (New York: Farrar Strauss Giroux, 1978); Ben Maddow, *Edward Weston: Fifty Years* (New York: Aperture, 1973).

4. Ben Maddow, *Edward Weston* (New York: Aperture, 1978), 9. All further citations from Maddow's biography are from this paperback edition.

5. Maddow, 110.

6. Maddow, 77.

7. Maddow, 57.

8. Maddow, 50.

9. Maddow, 73.

10. Maddow, 93.

11. Peter C. Bunnell, ed., "Form," *Edward Weston on Photography*, (Salt Lake City: Peregrine Smith Books, 1983), 158.

12. Kenneth Clark, *The Nude: A Study in Ideal Form* (New York: Doubleday, 1956), 29.

13. Clark, 25-27.

14. In discussing the nudes of Modotti, Maddow notes that one he admires is "almost unique; it has both the beloved's face and her sex," which he notes is "rare for Weston, perhaps as much for psychological as compositional reasons" (63). Maddow does not, however, pursue the insight.

15. Weston was all his life uneasy about the degree of abstraction that was appropriate in art. In a famous passage in the *Daybooks*, for example, when he contemplated the success of his Mexican portraits (many of which are, it seems to me, erotic), he was brought to write, "I shall let no chance pass to record interesting abstraction, but I feel definite in my belief that the approach to photography is through realism" (Nancy Newhall, ed., *The Daybooks of Edward Weston*, vol. I [Rochester: George Eastman House, n.d.], 55).

16. *Time*, 3 Sept. 1979, 44.

17. Maddow, 109.

18. Maddow, 111.

19. Maddow, 97.

20. Maddow, 117.

21. Maddow, 122.

22. John Szarkowski, "Edward Weston's Later Work," Beaumont Newhall and Amy Conger, ed., *Edward Weston Omnibus: A Critical Anthology* (Salt Lake City: Peregrine Smith Books, 1984), 159.

23. Maddow, 120.

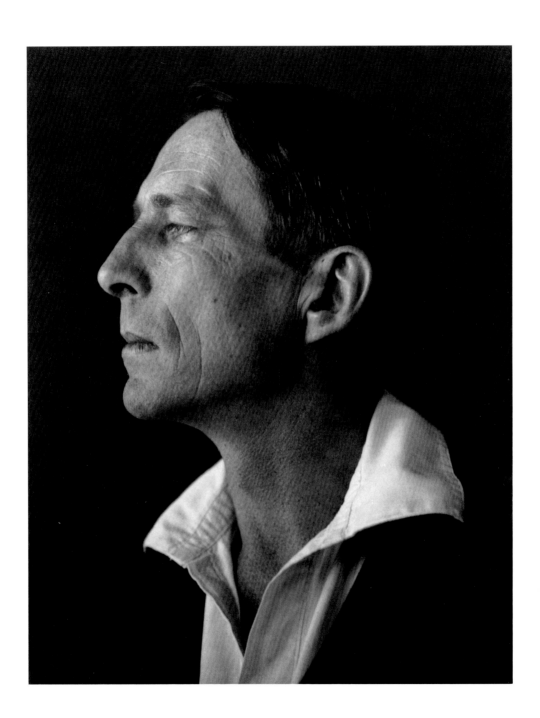

CARMEL'S CULTURE AND NATURAL SETTING HAVE FASCINATED some of the most celebrated authors and artists California claims. Writers as diverse as Robinson Jeffers (plate 3), Jack London, John Steinbeck and Robert Louis Stevenson all found some essence critical to their aesthetic needs in the region's environment and topography and brilliantly described the setting of Carmel and the Monterey Peninsula. Others have taken on the diffuse task of reporting factually on the area's development through books such as Franklin Walker's *The Seacoast of Bohemia* and the encyclopedic *A Tribute to Yesterday* by Sharon Lee Hale. Helen Spangenberg's history of the arts in Carmel brings together more names of active artists than other authors, but here I have necessarily limited myself to writings from a few sources, mostly photographers who worked in Carmel. From their letters and interviews I have followed outward to artists they knew and activities they shared and described. Exhibitions, picnics, portraits, performances, publications and art schools figure prominently in their recollections.

Looking back to 1929–1935 in Carmel, when Edward Weston first lived there, many elements of the town's culture seem gloriously simple. Yet this small community was uniquely beneficial to the bohemian gathering of practicing artists who lived or visited there, and their work ultimately reached an audience far beyond the geographic confines of the village. Weston arrived in Carmel to live in January 1929. He came to a small town with a large population of writers, painters and art students. This "artistically inclined" group was partially the result of an unusual land development plan that evolved in hope of making Carmel-by-the-Sea an aesthetically appealing refuge for those who could appreciate its picturesque surroundings. In 1925 an enthusiastic resident, Stephen Allen Reynolds, asked, "What is Carmel?," and answered his own question.

Truly we cannot answer. It is . . . unlike any other community on the face of the earth. It is the Nantucket of the West—colorful, flowerful, unique; conservative, liberal; sad, mad, reposeful, startling; artistic always. Carmel is a cocktail. In it we find the beauties of nature blended with romance and history. In it is a suspicion of Florence, two fingers of Amalfi, a dash of Anacapri as seen from the parapet of The Paradiso. Sweetened with a lump of moon-drenched Rome, a poppy behind our ear, we stir with our finger and sip slowly while [gazing] across snowy dunes at a cobalt and silver sea.[1]

CARMEL:

Beneficial to Bohemia

BY

THERESE THAU HEYMAN

PLATE 3, OPPOSITE:
Edward Weston,
Robinson Jeffers, Tor House, 1929.

Later in Reynold's description, he talks of the population.

The clang of the trolley-car is not heard in the land. Here are earnest folk who do fine things. Here also are clowns and dabblers at the various arts, eager to breathe the same air with genius, to glow in its reflected light. . . . One may wear a smock, prate of batik or Ibsen, for all one's neighbor cares. One may part his mane in the middle, perch shell-rimmed glasses on his nose, and to all intents and purposes he becomes a stone in the literary mosaic of Carmel. Nobody cares a hoot from whence comes the money to foot the bills. For Carmel, above all things, is tolerant and uninquisitive.[2]

These qualities likely appealed to most residents and particularly to Weston, who, in order to balance the care of his sons with artistic growth, needed this kind of tolerance. He contrasted his new home with what he had known in San Francisco. "When I think of the unbroken rows of houses, people canned as it were, the massed emanation from these huddled thousands, I catch my breath."[3] From the start Weston saw what Carmel would permit. "Besides work we have had recreation, a dip in the ocean, long walks through the hills and along the beach. This is what I wanted. . . ."[4] How, then, did this unusual environment evolve to be supportive of artists such as Edward Weston, who came to creative maturity during his residence there?

Carmel and the Peninsula had a strong Spanish influence—the Alta California capitol had been in Monterey—but the physical fabric of that heritage was rapidly declining by the time the state joined the Union in 1850. Robert Louis Stevenson, who lived in Monterey for three months in 1879 and is said to have used the region as his model for *Treasure Island*, reported, "The church [Mission San Carlos] is roofless and ruinous." Furthermore, in that early period there was almost no one living along the bay, although painters often followed the old pack-trail road, El Camino Real, up the coast looking for "scenes of wonder." Some, like Frederick Ferdinand Schafer, whose often dark, murky, atmospheric oil paintings in the almost "Tonalist" style were typical of many painters of the late 1880s, did set down the classic Carmel topography. Schafer's *Carmelo Bay* canvas (figure 5) conveys the thrusting energy of the sea and the power of the wind in the forms of the Monterey cypress. It also depicts Bird Island, with its white guano crown and constant company of birds. Schafer was clearly a match for these dramatic, restless landscapes, for as one critic observed, "His brush never [stops] in its rapid flight over his canvas."[5] Even in this workman-like effort, the vocabulary for the Carmel scene is

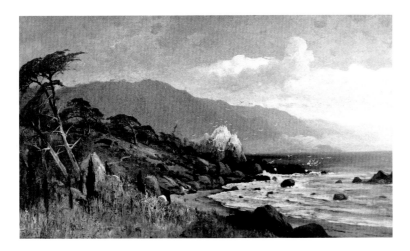

suggested. At that time, Carmelo Bay was a place to paint and camp out in, but not yet a site for an artist's studio.

In the next decade, a short-lived town called Carmel City offered land for only twenty dollars a lot, but buyers remained in short supply. Not until 1903 did the present Carmel-by-the-Sea "village," which was developed by James Franklin Devendorf and Frank Powers, take hold. A few years later, the author George Sterling and his friends—the poet Mary Austin and writers Jack London and Jimmie Hopper—gathered there as guests and residents, encouraged by the "natural life," the low cost and the leisurely financing of land purchases. After April 1906, Carmel offered a more timely refuge from urban life as displaced city dwellers moved away from the noisy reconstruction taking place throughout San Francisco following the earthquake and fire. One painter who fled, J. H. E. Partington, camped with the Sterlings and completed a few oils depicting the land in a comfortable, welcoming, sunlit manner.

Jack London, in his 1913 novel *Valley of the Moon,* described the hazards of the Carmel beach with one lone naked figure braving the powerful sea. Far safer than swimming alone, though, was the delight found in picnicking. Most writers who visited Carmel in the teens and twenties tell stories of the fresh catch, and photographer Arnold Genthe, who was one of the early residents of the village, reported on the abalone that Sterling and Hopper caught in the deep water by the cliffs. "The abalone would then have to undergo an hour's pounding with stones—we all took a hand at it."[6]

At times, this unmarred setting seemed to provoke or require a romantic address, or the imposition of ideas that had little to do with the light and the landscape. The frequently idyllic narrative celebrations of the ease and beauty of life on the Carmel coast were intertwined with repeated and sometimes eccentric attempts to link this new place of new experiences to the classical past of other cultures. Mary Austin spent days in the garb of an American Indian princess; Gertrude Atherton, the novelist, enjoyed searching for her identity as an "authentic" Spanish *doña*; Jack London exercised his convictions about the social order by speaking to his Carmel friends as a classical European socialist. Perhaps a natural setting sublimely indifferent to both artists and entrepreneurs evoked these responses. Perhaps the delight of life in a community uninhibited by prevailing social mores fostered them.

The poet Robinson Jeffers arrived in Carmel in 1914, and, as a result of what he found in Carmel and along its coast, the theme of the land as essential to healing quickly became evident in his expression. Ordinary readers, however, were more likely to have made contact with Carmel through Upton Sinclair's praise for the community's writers in the national press. Sinclair stayed at Genthe's home and partied with Sterling and others. His many books offering economic solutions to world ills were widely popular at the time, but a more modest and lasting aspect of his interests appears to have been very influential as well. His earnest regard for the benefits of a new diet—vegetables, nuts and tomatoes—impressed Carmel residents and may have been one of the reasons that Weston and his friends periodically returned to eating simple natural foods. With visitors such as Sinclair and the growing number of Stanford and University of California professors who owned homes in Carmel and summered there, the town's viability was well established, and in a form surprisingly close to the ideal of a "cultural community" its founders had sought.

Arnold Genthe bought land in Carmel in 1903, noting the easy terms that would encourage writers and "kindred spirits." He began to build his bungalow with the sensitivity to natural surroundings that came to characterize many later homes in the area. Placed in the shadow of the two largest pine trees on the site, the home had a slanted roof that carefully echoed the shape of the hills beyond. The four grand redwood tree trunks that supported the roof were left with bark intact, and the central room was fashioned of solid redwood beams. Even though he

no longer owned the house when he wrote his autobiography thirty years later, Genthe was able to keep these details of the construction vividly in mind because of the "color plates" that he made in 1906.[7]

Among Genthe's Autochromes from the next decade was *The Poppy Field* (figure 6), a photograph of a pretty woman, Helen Cooke, in a field of flowers. His recollection of the image evokes the synthesis of life, art and contemplation in early Carmel.

There came to the colony a tall, gangling young man in his early twenties. He had a head of unmanageable red hair and a freckled face and a pair of remarkable blue eyes, the pupils of which were darted with light. He and I would often walk together through the woods, indulging in philosophical discussions, sometimes lapsing into German, while we both knew that, more than with philosophical problems, our thoughts were concerned with the lovely Helen Cooke (the woman in THE POPPY FIELD*) to whom we were both devoted. Some years later she married Harry Leon Wilson. The young man was Sinclair Lewis, and if anyone had told me then that he would be the first American to be awarded the Nobel prize for literature, I should not have been particularly surprised."*[8]

Genthe would have been fascinated and perhaps not surprised to learn that Helen Cooke's daughter, Charis Wilson, became Edward Weston's wife some twenty years later.

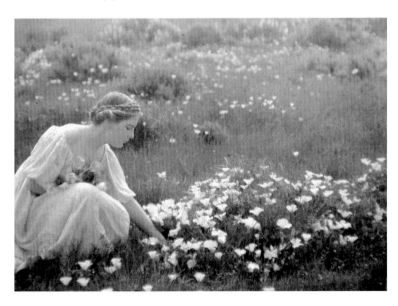

FIGURE 6:
Arnold Genthe,
Helen Cooke, Monterey Poppy Field,
1908.

Good-looking women usually attracted Genthe's attention. He was sure to photograph personalities of note, like Nora May French, (figure 7). Drawn to Carmel by the opportunity, if not the likelihood, of becoming a noted writer, Nora Mae seemed remarkable in her time. Blond and blue-eyed, she enticed George Sterling, who provided her some refuge in the tent house of his front yard. His wife Carrie reported, "She is a freak and has a dozen wheels all going at once. I'd rather read her poetry than have her company."[9] Sterling wrote of Nora Mae, and of the sense of danger present in many writers' lives, in the sonnet that mirrors Carmel's topography with Nora's troubled life and suicide.

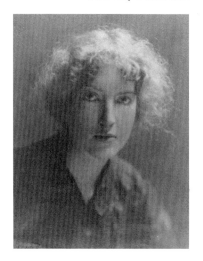

FIGURE 7:
Arnold Genthe,
Nora May French, n.d.

> *I saw the shaken stars of midnight stir,*
> *And winds that sought the morning bore to me*
> *The thunder where the legions of the sea*
> *Are shattered on her stormy sepulcher,*
> *And pondering on bitter things that were,*
> *On cruelties the mindless Fates decree,*
> *I felt some shadow of her mystery—*
> *The loneliness and mystery of her.*
> *The waves that break on undiscovered strands,*
> *The winds that die on seas that bear no sail,*
> *Stars that the deaf, eternal skies annul,*
> *Were not so lonely as was she. Our hands*
> *We reach to thee for Time—without avail,*
> *O spirit mighty and inscrutable!*[10]

Another prominent photographer who was drawn to Carmel by its emphatically cultural outlook was Johan Hagemeyer. During 1924 he lived in Carmel in a cottage he designed and built at Ocean and Mountain View Avenues, and he subsequently split his time between San Francisco and Carmel. He also opened the first studio gallery in the village to show "modern photographs and graphic arts and informal evenings of music."[11] At the end of 1928, Hagemeyer agreed to rent this studio cottage to Edward Weston. As a chronicler of culture, Hagemeyer was something of a misanthrope; but he contributed a knowledge of music as well as a European literary viewpoint. Here, according to Hagemeyer, are those who actually pursued aesthetic matters in Carmel:

Women know more about the arts. Men are grinders here; they must bring home

the bacon. And they love it; they love the success of their business, but they have no time for anybody else.[12]

If pressed, Hagemeyer would admit to knowing a few painters of talent like Armin Hansen and C. S. Price, but his vision of Carmel was that it was essentially a place to go for vacation or a honeymoon.

Although the neighboring communities of Del Monte, Pebble Beach and Carmel Valley were each distinctive in style and economic base, they were close enough for cultural and social exchange. Distances were easily travelled. George Sterling wrote of a 45-minute walk from Monterey to Carmel for a lecture. Photographer Roger Sturtevant was closely associated with the Weston circle and had shared a studio with Johan Hagemeyer in 1927; later he shared a studio with another San Francisco Bay Area associate, Dorothea Lange.

Roger Sturtevant is listed as one of the guests at a late September 1929 fancy dress party Weston gave as a farewell for his close friend Ramiel McGhee. *The Carmelite* newspaper called it the "social event of the year," adding that Sturtevant came costumed as an "ultra modernist," while Weston predictably was dressed as the king of the revellers.[13]

At one point in the lengthy interviews Sturtevant taped to provide a context for his large archive of architectural and portrait photographs, he noted:

I was always a little iconoclastic, so my answer to the current vogue (magnolia blossoms and botanic specimens photographed close-up) was to find some of these primitive sinister fronds of ferns and pick them and place them with some ordinary sheets of broken glass in curved shapes. (From this) I make various compositions [figure 8]. The other work, the Keds (Ron Partridge's in the old wash bucket), was in 1929, I was in Carmel. Weston probably walked into the studio and these photographs were among the things that he leafed through and took [figure 9].[14]

The events that captured most of the attention of Carmel's photographers and artists were the amateur theatrical performances that were the beginning of the little theater movement. These were held at the Watrous-Denny Golden Bough Theater, which produced many contemporary plays such as *Hedda Gabler*, *The Emperor Jones* and *Ghosts*.

As the 1920s passed, an increasing number of art students were attracted to Carmel by classes taught by noted painters such as William Merrit Chase and Armin Hansen, who started the Monterey Art

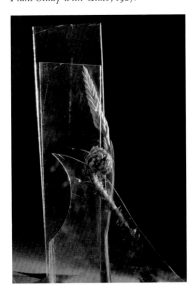

FIGURE 8:
Roger Sturtevant,
Plant Study with Glass, 1927.

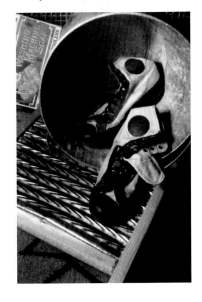

FIGURE 9:
Roger Sturtevant,
Werbefoto Um 1926, 1927.

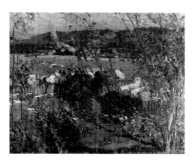

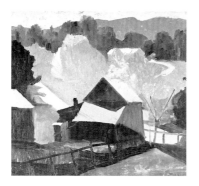

School. These precursors of modern workshops offered serious students an opportunity to study in a setting particularly suited to the painting styles of the time.

A kind of American-style Impressionism prevailed during the 1920s that, when associated with indigenous aspects, might be termed "California Impressionism." The California forms of this no-longer-radical style were taken up and modified by E. Charlton Fortune in paintings like *Monterey Bay, 1916*, (figure 10). Painted outdoors, it is full of light but concentrates on the intimate elements of landscape—the house and the tree limbs screening the harbor. The usually warm and often sunny Carmel area provided a full visual array for the brushy Impressionist outdoor paintings that required quick execution to capture the changing effects of light, as in the *Ranch in Carmel Valley* by August Gay, (figure 11).

California Impressionism was, in many ways, a late-blooming variety of a style that was begun abroad much earlier under circumstances similar to those that prompted the development of the photographic style of Pictorialism. If the diffused light of Carmel rendered by California Impressionists had a photographic equivalent, it is probably to be found in this quality of Pictorialism.

The pre-1932 Carmel works of John Paul Edwards, for example, (figure 12) exhibit soft focus and a naturalistic view; they share qualities of light with the works of Carmel Impressionist painters August Gay and C. S. Price. The California Pictorialists argued their cause with those who later came to oppose them, a group that included Edwards, in numerous articles in *Camera Craft*. Among the most entertaining and vitriolic of these were by William Mortensen, who sharpened his arguments on mood, atmosphere and creative Pictorialism in the lengthy series published in the early 1930s. It was the response to this writing, in particular, that led to the creation of Group *f*/64.

A number of San Francisco Bay Area galleries provided important forums for Pictorial painting and photography, as well as for modern work, between the turn of the century and 1932, when the initial *f*/64 exhibition opened at the de Young Museum in San Francisco and firmly established a stylistic turning-point for California photography.

In the earlier period, when Weston and most of the *f*/64 group were still Pictorialists, their work was often seen in shows and salons. A Weston show was planned in 1919 at the Oakland Art Gallery, for

example, and there is a slim file referring to an exhibition of prints to be arranged by Worth Ryder, who was then the gallery director. These rare photographs may be the ones that were listed in a 1921 Pictorial annual produced by the Gallery. The file contains a letter on the *Edward Henry Weston* letterhead, that Weston seems to have used at that time referring to a trade of art works with Worth Ryder.

During the early 1930s, the Carmel art community continued to take its lead from conservative older masters such as Arthur and Lucia Mathews (figure 13), whose California Decorative Style pleased and influenced others and was embodied in the Carmel Art Association. The prize-winning William Ritschel, who was a founding member of the Association and eventually its president, worked with the members to provide adequate exhibition space for local artists. By 1929 the Association had two hundred members[15] and wished to build gallery space; by 1933 the concentrated efforts of artists and dependable art patrons, the all-too-usual auctions of artists' paintings and an exhibition of the most recognized painters—which included four National Academicians—produced funds for the new building, along with a call to raise the quality of art submitted for exhibition. Ironically, the Association membership allowed only painters and sculptors to join. Weston and his circle, however, would have looked in other directions; by this time "Modernism" was assumed by them.

Weston described "Modern Art", as it was understood in the 1920s, in a 1940s letter to Nancy Newhall.

Modern Art is being used to index me. Surely it was a source but photographers have influenced Modern Art quite as deeply as they have been influenced, maybe more. Anyway painters don't have a copyright on M.A. We were all born in the same upheaval.[16]

Despite the fact that the inconveniences of tourism eventually became the negative residue of Carmel's magnetic quality as a resort, the community attracted a continuous caravan of interesting visitors who soon formed a significant ingredient in the life and culture of Carmel. One particularly memorable and determined woman, Galka Scheyer, arrived in Carmel in the late 1920s as a kind of outrider for the cause of modern art.

Her missionary zeal for introducing new art began in the early 1920s, following her art studies in Germany. She arranged traveling exhibitions

FIGURE 12:
John Paul Edwards,
The Strollers—Carmel Beach, Monterey Coast, 1918.

FIGURE 13:
Arthur F. Mathews,
Dancing Girls, n.d., oil on canvas.

and presented didactic lectures to explain the work and to insure a future audience. To provide a meager income to support her art interests, she taught at progressive private high schools like the Anna Head School in Oakland. Scheyer would have been remarkable in any American small town of the day, but in Carmel and Oakland, she was unique. Her crusading spirit and her whirlwind travels to Europe and Bali to arrange exhibitions were in direct contrast with the quiet, stationary life of the Carmel Art Association and the Oakland Art Gallery.

Scheyer came to Carmel as a self-styled agent, as the European representative of the Oakland Art Gallery and the American representative of the Blue Four—Paul Klee, Vassily Kandinsky, Alexej Jawlensky and Lionel Feininger.[17] This role, or mission, necessarily kept her in constant touch with the "modern" in art, and through the 1930s she waged a crusade to win recognition for the Blue Four on the West Coast, all the while educating and involving her friends in their cause.[18] These "art radicals," as she called the Blue Four, were considered somewhat crazy by local painters in Oakland and in Carmel, but not all the response to Scheyer's advocacy was parochial in nature. For Weston's friend, Diego Rivera, the great Mexican muralist who was then teaching and painting in California, "The Blue Four needs no praise from anyone whatsoever. Their role in the Art of the World has been for many years of the greatest importance."[19]

Scheyer became a kind of catalyst for the forces of modernism that were confronting the prevailing aesthetic tendencies of many artists in Carmel, and one of those she introduced to "modern art" was Edward Weston.

Since Carmel was removed from the main centers of American art, it afforded, as one critic wrote, a peculiar "expressionistic" approach to the then current style of painting because there was "the freedom to experiment that is the advantage of the provincial artist."[20] This quality —which might be called regionalism—can also be seen as a "need to combine that remote world's aesthetic ingredients into movements that would not only be American, but that would be indigenous to the local area."[21] This distance from major art centers permitted a strong artist to find his own way. Edward Weston and Robinson Jeffers may thus each be seen as benefitting from Carmel's location between, but not in, the creative centers.

Considering the importance of modernism to his developing

expression, why was Edward Weston content to live in Carmel from 1929 to 1935 and then return to it only a few years later? According to his son Cole, "Aside from his apparent genius . . . simplicity was the most important factor influencing his work . . . Weston lived and worked with the barest essentials."[22] In Weston's home on Wildcat Hill (built by Neil in 1938 for a legendary $1,000), Cole notes that there was a one-room studio, with one bed and a single table for conferences, work and dining. Food was simple, as were camera and darkroom equipment. While Weston's daybooks reflect complex, often crowded relationships with many friends and lovers, it was as if a necessary simplicity was central to his performance in life as well as in art.

The ambiance fostering the ease, privacy and creativity that attracted the early artists and writers to Carmel proved to be more fragile than the rugged seacoast and tough, wind-sculptured trees. Charis Wilson, with refreshing wit and charm, remembers that although the Westons continued to return to Carmel, she and Edward shared a sense that "Carmel engendered a self-satisfaction and smugness about its importance. . . . When we moved to the Highlands in 1938 we were quite removed from town."[23]

In many American towns, "culture" is usually understood to be man-made; but in California, and particularly in Carmel, it sometimes seems possible to credit nature and the natural order as this agency. For many amateurs and enthusiasts, the natural beauty of the area seemed to suggest that any creative work undertaken there would benefit from the physical setting. But Weston wrote of the "poor abused cypress— photographed in all their picturesqueness by tourists, 'pictorialists,' etched, painted and generally vilified by every self-labeled 'artist.' "[24] In fact, trees were a theme of such pervasive interest that they became the subject of a 160-print juried exhibition just before the seminal Group f/64 presentation at the de Young Museum in San Francisco. First prize went to Edward Weston, second to Alma Lavenson, fourth to Ansel Adams and seventh to Willard Van Dyke.[25]

However important the natural order continued to be in the development of Carmel's culture, the thirties saw markedly different concerns in urban centers. Skyscrapers were photographed from every conceivable angle as acknowledged symbols of progress, an American theme. In turn, scenes of the coast came to symbolize an Eden out of touch with the times and led to many scornful evaluations of California.

Walker Evans delivered one version.

Photography is not cute cats, nor nudes, motherhood or arrangements of manufactured products. Under no circumstances is it anything ever anywhere near a beach.[26]

Weston had to have been thinking about criticism of his refusal to be involved in the difficulties of modern living when he concluded:

Is this sojourn in Carmel an attempt to escape, a refusal? Not at all! I am not a reformer, a missionary, a propagandist,—not in a militant concrete way. I have one clear way to give, to justify myself as part of this whole,—through my work. Here I can work, and from here I send out the best of my life, focussed onto a few sheets of silvered paper.[27]

By the time that Edward Weston and Charis returned to Carmel from their Guggenheim and Whitman trips, they agreed that Carmel was living on its past bohemian reputation. Carmel had been a place where talented writers and landscape artists gathered; but, by the late thirties, few younger bohemians were joining the community. Weston and Charis moved into Carmel Highlands, where they remained purposely distant from Carmel artistic activities. Weston had effectively managed to build an enviable reputation as a fine art photographer from Carmel, but that national reputation evolved in some part from his personal conviction, as much as from direct geographic support. Weston believed, as he wrote to his sister early on, that, "I'm going to make my name so famous that it won't matter where I live."[28] True, today his name, as well as his photography, is celebrated. Equally true, Weston's photography is intricately concerned with Carmel.

NOTES

1. Stephen Allen Reynolds, *Carmel: Its Poets and Peasants* (Carmel: Pine Cone Press, 1925), 1.
2. Reynolds, 2.
3. Edward Weston, Nancy Newhall, ed., *The Daybooks of Edward Weston, Volume II. California* (Millerton, N.Y.: Aperture, 1973), 107.
4. Weston, 107.
5. "What is Art," San Francisco Chronicle, April 11, 1886.

6. Arnold Genthe, *As I Remember* (New York: John Day, 1936), 75.

7. Genthe, 73.

8. Genthe, 76.

9. Franklin Walker, *The Seacoast of Bohemia* (Santa Barbara: Peregrine Smith, Inc., 1973), 32.

10. Walker, 9.

11. *Carmelite*, 1928.

12. Johan Hagemeyer, interviewed by Corinne L. Gilb, January 23, 1956, transcript, Berkeley Regional Oral History Project, The Bancroft Library, University of California, Berkeley, 40.

13. Review, Center for Creative Photography Archives, University of Arizona, Tucson, September 1929, 12.

14. Roger Sturtevant Collection, Archive Interviews, The Oakland Museum.

15. Betty Hoag McGlinn in the pamphlet, Roots of the Carmel Art Association, 1969.

16. Weston-Newhall Correspondence, Center for Creative Photography, University of Arizona, Tucson.

17. The Oakland Museum Archives.

18. Edward Weston is listed as a lender of a colored lithograph by Kandinsky (no. 70) to the notable *Thirty European Modernists* exhibition at the Oakland Art Gallery, January 1928.

19. Blue Four Catalog, The Oakland Museum Archives.

20. The Oakland Museum Art Department, *Impressionism: The California View* (Oakland: The Oakland Museum, 1981), 14.

21. The Oakland Museum Art Department, catalog for: *Society of Six: William Clapp, August Gay, Selden Gile, Maurice Logan, Louis Siegriest, Bernard von Eichman* (Oakland: The Oakland Museum, 1972), 16.

22. Cole Weston, "Classics of Photography II," *Popular Photography*, May 1969, 66.

23. Charis Wilson Weston, June 1985, interview with author.

24. Weston, *The Daybooks*, 114.

25. Exhibition announcement, University of California, Forestry Library, 1955.

26. Jonathan Green, *American Photography* (New York: Harry N. Abrams, 1984), 23-24.

27. Weston, *The Daybooks*, 207.

28. Kathy Kelsey Foley, *Edward Weston's Gifts To His Sister* (Dayton: The Dayton Art Institute, 1978).

QUINTESSENCES:

Edward Weston's Search for Meaning

BY ESTELLE JUSSIM

IF YOU GREATLY ADMIRE MANY OF EDWARD WESTON'S PHOTO-graphs—as I do—and if you find them aesthetically majestic, recognize their substantial influence and their high status in contemporary criticism, you may turn to the photographer's writings in an effort to discover his intentions, his philosophies, perhaps even his secrets. Expect complexity.

As you begin to study Weston's prolific writings and his numerous statements about his own work, you quickly encounter the word *quintessence*, which he used to describe his primary goal in photography —to reach, with the aid of the piercing "honesty" of the camera, beyond superficialities to the quintessence of an object. A moment later, however, you read that he wants to make a rock *more* than a rock, a tree *more* than a tree, an apple *more* than an apple, a pepper *more* than a pepper. Continuing on, you will find that he vehemently opposes what he calls interpretation, but concedes that each person will have his or her own idiosyncratic reaction to both objects and photographs. If you are a photographer yourself, you may be unduly gratified by Edward Weston's insistence that "photography admits the possibility of consid-erable departure from factual recording,"[1] but wonder what he meant by saying that his goal was "direct presentation of THINGS in THEMSELVES."[2]

For how can you make a direct presentation of things in themselves, and yet depart considerably from factual recording? How can you reveal the quintessence of an object, yet make it more than it is? How can you avoid interpretation, yet remain yourself, with your own subjective reactions? Are these ideas contradictions in Edward Weston's thinking, or did he somehow find a way to reconcile seemingly disparate implications?

There was much to reconcile. In an early statement in 1922, Weston concluded in a lecture that his ideals of pure photography (he had only lately given up Pictorialism) were much more difficult to live up to in the case of landscape, "for the obvious reason that nature—unadulte-rated and unimproved by man—is simply chaos. In fact, the camera proves that nature is crude and lacking in arrangement...."[3] Nine years later, in a 1931 statement, Weston declares:

I am not trying to express myself through photography, impose my *personality upon nature (any manifestation of life) but without prejudice or falsification to*

become identified with nature, to know things in their very essence, so that what I record is not an interpretation—my idea of what nature should be—but a revelation or a piercing of the smoke-screen artificially cast over life by irrelevant, humanly limited exigencies, into an absolute, impersonal recognition.[4]

Given the obvious fact that all of us change our opinions over time, and are entitled to do so, how did Weston travel philosophically from the idea of nature as chaos to a desire (and an ability) to become "identified" with nature? Did he notice the implication in his 1931 statement that *he* was capable of rising above "humanly limited exigencies" to an "absolute, impersonal recognition?" Later in that statement, Weston attempted to clarify his position by this declaration of his goal: "To present the *significance of facts*, so that they are transformed from things *seen* to things *known*."[5] He does not explain how he became endowed with what might be interpreted as godlike capacities.

Unfortunately for Weston's line of reasoning, the facility for recognizing the significance of facts varies considerably from human to human, since it is the idiosyncratic individual who assigns values to everything he or she encounters. The camera, of course, is a machine that cannot assign value, in the sense of significance. For all Weston's frequently iterated desire to achieve an absolute, impersonal recognition, he explained just as often that it was the intelligence of the human being behind the camera who directed it to its ultimate achievements. As for identifying with nature, one solution that worked for Edward Weston was to isolate fragments of nature. At the same time, however, he was able to deal magnificently with monumental aspects of nature—the dunes at Oceano, tomato fields polka-dotting toward the horizon, the poignant evanescence of tidal pools at Point Lobos, the plunging surf with the fog obliterating the Big Sur coast. Making selections out of the chaos of nature was precisely what photographers had been doing since the beginnings of the medium, for it was—and will always be—impossible to depict *all* of nature in one image.

In 1930, Weston wrote:

. . . the camera for me is best in close-up, taking advantage of this lens power: recording with its one searching eye the very quintessence of the thing itself [emphasis added] rather than a mood of that thing—for instance, the object transformed for the moment by charming, unusual, even theatrical, but always transitory light effects.[6]

Since he would later insist that "reflected light is the photographic subject matter,"[7] the statement above is either mistaken, misleading or self-deluding. Unless rigorously controlled by artificial means, *all* light effects are transitory. The sun continues to move across the sky, clouds pass overhead, shadows come slanting down from houses, mountains, trees. As for the phrase *even theatrical*, no one can deny that Edward Weston stage-managed his props exceedingly well, skillfully controlling lighting rather than light, although he would have insisted that just the opposite was true. The searching eye he attributes anthropomorphically to the camera lens is obviously the masterful eye of Weston himself, and this is demonstrated all too clearly in his 1939 article, "Light vs. Lighting," in which he describes the infinite pains he took with just one pepper.

At the time I made it I was doing a great deal of still life work and my 'studio' consisted of a porch open on three sides and screened at the top by an awning of cheese cloth. This particular pepper occupied me for several days. It seemed almost impossible to get all of its subtle contours outlined at once—I put it against every conceivable kind of background, light ones and dark ones; I put it on the ground in the shade, against the sky in the sunlight. I worked several days and made half a dozen negatives, but each time I knew I was wrong, I wasn't getting it. Then in a try-everything-once spirit I put it in a tin funnel and the moment I saw it there I knew my troubles were over. No direct light was needed.[8]

Was Weston struggling here with the quintessence of a pepper, or was he, like any photographer, simply seeking the best way to describe the physical forms of an object, to make an acceptable negative and, ultimately, a handsome, or at least interesting print?

What is this quintessence Weston keeps mentioning? Look at four pictures: *Pepper No. 14, 1929* (plate 4), *Wrecked Car, Crescent Beach, 1939* (figure 14), *Surf, Orick, 1937* (figure 15) and *Knees, 1929* (figure 16). When you look at these, are you struck by *essences*, or by the superlative composition of each picture? They are superlative in the modernistic sense, composed strikingly within the rectangle, relating negative and positive spaces beautifully, contrasting mass and volume with emptiness, modelling flatness versus three-dimensionality; you can perhaps marvel at the equilibrium of various elements. This equilibrium is nowhere more conspicuous or satisfying than in the passages of light grey tones to darker tones that incorporate staccato stabs of still darker

FIGURE 14:
Edward Weston,
Wrecked Car, Crescent Beach, 1939.

shapes as the eye travels along the various diagonals of *Wrecked Car, Crescent Beach.* Does one think, "This is the essence of wrecked car?" If so, Weston would have failed by his own account elsewhere, for he often stated harshly that photography had nothing to do with either illustration or literary allusions. Yet if you find yourself going beyond the dubious response of "this is the essence of wrecked car" to "so we must all of us come to dust—or rather, rust," you are allowing precisely the kind of vague sentiment that Weston claimed to despise. Weston would have insisted that he wanted us to look at the visual music of his picture for the subtleties of pure form he had discovered and brilliantly arranged in his ground glass.

Weston was persuaded that his pepper, for example, was beyond any literary allusion or sentiment.

It is classic, completely satisfying—a pepper—but more than a pepper; abstract, in that it is completely outside subject matter. It has no psychological attributes, no human emotions are aroused: this new pepper takes one beyond the world we know in the conscious mind. To be sure much of my work has this quality—many of my last year's peppers, but this one, and in fact all the new ones, take one into an inner reality—the absolute—with a clear understanding, a mystic revealment [sic]. This is the "significant presentation" that I mean, the presentation through one's intuitive self, seeing "through one's eyes, not with them," the visionary.[9]

One of his fervent admirers, nonetheless, wrote of this presumed absolute pepper, "fancy sees it as a human torso poised with grace and strength; another [pepper] might be a modernist conception of man's struggle to evolve from lower forms."[10] Others, as Weston admitted, saw in his absolute essence of pepper the female vulva, the male penis, sexual intercourse, men wrestling and all manner of hated Freudian things. While Weston was congratulating himself on having found a way to make peppers abstract and beyond subject matter, his audience was bemused (and often amused) by the presence of so many similes, analogies and metaphors.

Weston confessed that few edibles excited him as much as a box of peppers down at the grocer's, as he also admitted—he was in analysis at the time—the possibility of sexual eruptions from his own uncon-scious.[11] He defended his making perhaps fifty negatives of peppers "because of the endless variety in form manifestations, because of their extraordinary surface texture, because of the power, the force suggested in their amazing convolutions."[12] To be delighted by amazing convolutions is hardly equivalent to producing the vision, the essence, or the "mystic revealment" he mentions above.

Was Weston only indulging in self-delusion, or were there influential ideologies that pushed him toward modernistic preoccupations with pure form? There had been profoundly mystical underpinnings to modernism, many of them linked to theosophical idealism. Derived from Swedenborg's notions of "correspondences" between the physical and spiritual worlds, the essential belief of theosophy was that a parallel universe exists in which all ultimate, pure, ideal forms dwell, free from nature's transitory appearances. The phenomenological world was

illusion; truth existed only somewhere beyond our senses. Influential theosophists taught that human beings generate "thought forms" that are universal and emblematic of the spiritual world. When the abstract painter Wassily Kandinsky described these forms in *Concerning the Spiritual in Art* (1911), he influenced photographers like Stieglitz, and ultimately, Edward Weston.

Like so many modernistic photographers, Weston was intrigued by the possibility of a metaphysics of form, and fleetingly pondered the psychology of art. Once in a while, rather plaintively, Weston asked why it was that a combination of lines by Kandinsky, or a sculpture by Brancusi—all abstractions—could evoke intense response even if the

FIGURE 15: Edward Weston, *Surf, Orick, 1937.*

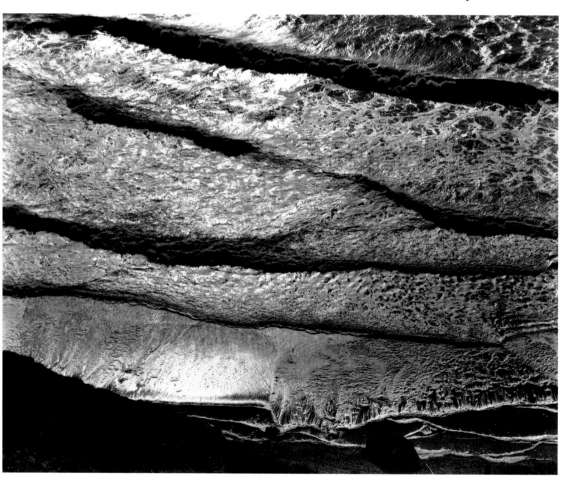

forms were unrelated to the phenomenological world. "Granted the eyes become excited, Why?"[13] Nineteenth-century artists and scientists had struggled to decipher and solve just such psychological and philosophical problems. What is innately recognizable? How and why do abstract forms stimulate our responses, and are these universal? The great semanticist Alfred Korzybski noted that it is merely language that links disparate forms, that we define "appleness," for example, by a set of characteristics that we assume belongs to all apples. Yet each individual apple is different from the next and is constantly in transition from one time-state to another, from one color and mass to ultimate dissolution. Korzybski might have said that Weston's preoccupation with revealing "quintessence" was as mystical as Weston admitted, and therefore totally unscientific.

Weston was persuaded that there is an underlying unity of life forms. In fact, despite his constant stress on quintessence, he saw a unifying force in all forms. In 1957, shortly before his death, he commented:

If there is symbolism in my work, it can only be the seeing of parts—fragments— as universal symbols. All basic forms are so closely related as to be visually equivalent *[emphasis added]. I have had a back (before close inspection) taken for a pear, knees for shell forms, a squash for a flower and rocks for everything imaginable!*[14]

As early as 1931, he had stated:

Life is a coherent whole: rocks, clouds, trees, shells, torsos, smokestacks, peppers, are interrelated, interdependent parts of the whole. Rhythm from one becomes symbols of all. The creative force in man feels and records these rhythms, these forms, with the medium most suitable to him. . . .[15]

Now, it is really rather stunning to discover—despite Weston's search for the rock that is more than a rock and the tree that is more than a tree —that no outward form mattered at all. What mattered was the "life force," a Bergsonian idea that infected many artists in the 1920s. Weston's enthusiasm about the interchangeability of forms, and his acceptance of a squash being taken for a flower and knees for shell forms, simply contradicts his continuing insistence that his search was for the squash *beyond* the squash. He was unable, or unwilling, to recognize that he was not reaching for essences at all, but for *ultimate essence.* Instead of seeking the soul of a pepper, the pepper beyond the pepper, the Platonic Ideal True Pepper, or the essence of pepperness, he

was trying to photograph the life force itself, that ultimate essence of all of the material world.

One critic, who reacted with an apparent sense of outrage at Weston's 1975 retrospective exhibition at the Museum of Modern Art, wrote acerbically:

Straight photography—whatever it is—is hardly exemplified by peppers like clenched fists, thighs like shells, shells like vulvas, palm trees like industrial smoke stacks—forms that Weston saw because he had seen modern art.[16]

The critic—Janet Malcolm—was, furthermore, unpersuaded by Weston's famous precision of detail. Modernistic art, she felt, was responsible for his achievements, but as for optical sharpness, it was "more an attribute of the buzzard's than of the human eye."

Stieglitz' blurry view of the Flatiron Building on a snowy day is surely more a literal rendering of "the thing itself" than Weston's razor-sharp close-up of a halved artichoke.[17]

What Malcolm was ignoring, of course, was the fact that Weston was not interested in what he called seeing *with* the eyes, but seeing *through* them. Malcolm's example was poorly chosen, for Stieglitz' blurry view was Impressionism, or seeing with the eyes. Weston's idea was to want "the greater mystery of things revealed more clearly than the eyes see, at least more than the layman, the casual observer notes. *I would have a microscope, shall have one some day*" [emphasis added].[18]

The implication that the ultimate in seeing through to the greater mystery of things would be made possible by a microscope has been largely overlooked in writings about Weston. Why a microscope? A microscope permits you to view what is truly beyond normal sight—the cellular structure of life. What if all of Weston's talk about quintessences and essences and seeing through rather than with the eyes was related, not to the greater mystery of things in a spiritual, theosophical sense, but in a very literal sense, and a desperate sense at that? For if you take Weston's desire for a microscope seriously and literally—and there is no reason why you shouldn't—then you must admit the possibility that one of the urges that drove Weston was something akin to a little boy's eagerness to learn about the mystery of life, or perhaps simply the mystery of birth, in the way that a biologist or zoologist would pursue it.

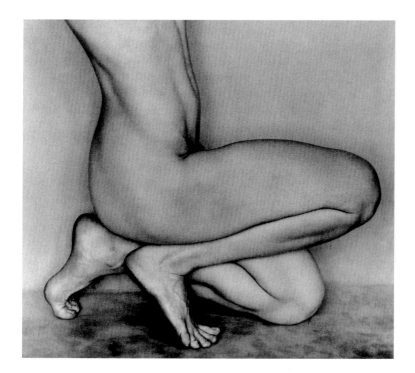

FIGURE 16:
Edward Weston,
Knees, 1929.

Other photographers, Alvin Langdon Coburn being an excellent example, sought to illuminate the mystery of life through religion and a variety of arcane, non-Christian, non-Western philosophies. Weston, too, followed his mysticism through similar creeds and ideologies, but there seemed always to be a very literal sense in which he meant the act of "seeing." In 1940, writing for the *Encyclopaedia Britannica*, Weston set forth what might be considered his ultimate statement about his approach to photography. He begins by stating that the camera has an innate honesty.

. . . it is that very quality which makes the camera expressly fitted for examining deeply into the meaning of things *[emphasis added]. The discriminating photographer can direct its penetrating vision so as to present his subject— whatever it may be—in terms of its basic reality. He can reveal the essence of what lies before his lens with such clear insight that the beholder will find the recreated image more real and comprehensible than the actual object.*[19]

Is Weston's "quintessence" to be equated with "the meaning of things?" Can you ask, "What is the *meaning* of knees? Of a wrecked car

on the beach? Of peppers? Of surf pounding on the shore?" Is not "the meaning of things" to be equated with his phrase "the significance of facts?" Did Weston intend that we should look at the razor-sharp slice of artichoke and ask, "What does an artichoke mean?" Did he simply want us to marvel at the geometric structure of nature as epitomized in the artichoke? Or did he want to light up the interior of an artichoke as he might have wanted to light up the very mystery of life?

Life is the ultimate mystery. It escapes even the electron microscope. The life-force is another such ultimate mystery. If we can accept the idea of ultimate mysteries, and recognize that these were the goal of Weston's imagery, then his passionately insistent but often confusing statements about "quintessences" and other contradictions can be reconciled, or at least forgiven. It is in the nature of ultimate mysteries that human beings find them inexpressible.

NOTES

1. Edward Weston, "Photography," 1934, in Peter C. Bunnell, ed., *Edward Weston on Photography* (Salt Lake City: Peregrine Smith Books, 1983), 74.
2. Nathan Lyons, "Weston on Photography," in Beaumont Newhall and Amy Conger, eds., *Edward Weston Omnibus* (Salt Lake City: Peregrine Smith Books, 1984), 170.
3. Weston, "Random Notes on Photography," 1922, in Bunnell, 31.
4. Weston, "Statement," 1931, in Bunnell, 67.
5. *Ibid.*
6. Weston, "Photography Not Pictorial," 1930, in Bunnell, 58.
7. Weston, "Light vs. Lighting," 1939, in Bunnell, 100.
8. *Ibid.*, 101.
9. Nancy Newhall, ed., *Edward Weston: The Flame of Recognition* (Millerton, N.Y.: Aperture, 1971), 34.
10. Frances D. McMullen, "Lowly Things that Yield Strange, Stark Beauty," in Newhall and Conger, *Omnibus*, 41.
11. Edward Weston, Nancy Newhall, ed., *The Daybooks of Edward Weston*, Vol. II. *California* (Millerton, N.Y.: Aperture, 1962).
12. Weston, *Daybooks*, 225.
13. Newhall, ed., *Flame of Recognition*, 8.
14. Weston, "Form," 1957, in Bunnell, 158.
15. Lyons, 170.

16. Janet Malcolm, "The Dark Life and Dazzling Art of Edward Weston," in *Omnibus*, 161.
17. *Ibid.*
18. *Flame of Recognition*, 42.
19. Weston, "Photographic Art," 1940, from the *Encyclopaedia Britannica*, 14th edition, in Bunnell, 132.

Weston, at least, felt that some of Tina's photographs were indistinguishable from his.[1]

. . . it would be impossible really to say whose photographs are which. . . .[2]

TINA MODOTTI AND EDWARD WESTON:

A Re-evaluation of their Photography

BY AMY CONGER

THESE STATEMENTS DESCRIBING TINA MODOTTI'S AND EDWARD Weston's photography represent an extreme point of view that some writers today have adopted, possibly in order to avoid lengthy and potentially tedious analyses of the works of these two artists. Neither facts nor careful visual studies of their prints, however, offer evidence to support these claims.[3]

On the contrary, as early as 1926 the painter Diego Rivera, then a close friend to both Modotti and Weston, published an article on their individual photographic accomplishments and commented:

Our sensibilities today are not fooled by the novelty of the camera process; modern men clearly feel the individual personality of each of the authors of different photographs, although made at the same time and in the same space. We feel the personality of the photographer as clearly as that of the painter, draughtsman, or printmaker.

Actually, camera and darkroom manipulations are a technique, like oil, pencil, or watercolor; and, above all, the means for expression of human personality.[4]

He added that he found Modotti's work "perhaps more abstract, more ethereal, and maybe more intellectual" than Weston's.

The fact that Modotti's style has been rather consistently ignored since then is partly due to the fact that she was not very productive. About 160 images have been identified as made by her from 1923 to 1930, dates that span her entire photographic career. On the other hand, more than 750 images by Weston have been located from his stay in Mexico from 1923 through 1926.[5] It seems that her style has also been passed over because of the quantitatively and qualitatively poor documentation that exists about her life, a lacking that is partially the result of her disdain for red tape and bureaucracy.[6] At the same time, Weston regularly recorded events that excited and interested him in his

PLATE 5, OPPOSITE:
Edward Weston,
Tina Reciting, VII, 1924.

daybooks and saved them. He also saved a significant part of his correspondence, a scrapbook of clippings from his Mexican exhibitions and a guest register from his shows there. He even saved suitcases with the hotel labels still attached.

Contemporary written material about or by Modotti consists almost exclusively of what is available in Weston's archive, which, fortunately, includes her letters to him. The last of these is dated January 1931, by which time her photographic career had ended. Much of the material available, however, has not been used. So little serious study of Modotti as a photographer has been done that no one has yet mentioned relevant points such as what cameras she used. Instead, her biographers have shown great interest in the fact that she was a woman who did not respect some values that were then conventional—and, consequently, have concluded that she must have been an ardent feminist. They have also emphasized the consistently outstanding men with whom she lived; her extraordinary beauty, as reflected in Weston's pictures of her nude, and the later political work she did for Lenin and the Comintern in Stalinist Russia and for the anti-Fascist forces in Spain during the Civil War.

Under the guise of studying her photographic achievements, writers and filmmakers have used her life as a vehicle for their own fantasies and ideologies. For example, critics recently wrote that "Modotti's work as a photographer can only be understood in the context of her private life and position as a woman."[7] In other words, her work should not be considered independently of gender or compared with that of men. The same critics also explain the small size of her prints—which was, of course, the same as Weston's—not in terms of camera, film, or paper size, but as a partial reflection of "the traditional constraints of woman's art."[8]

It seems ironic that evidence indicates that Modotti did not particularly enjoy the companionship of women. Nothing has survived to suggest that she had ever become indignant over the social and political status of her own sex. Weston commented that "There is a certain inevitable sadness in the life of a much-sought-for, beautiful woman, one like Tina especially, who not caring sufficiently for associates among her own sex, craves camaraderie and friendship from men as well as sex love."[9] In 1925 she wrote him:

I am convinced now that as far as creation is concerned (outside the creation of species) women are negative—they are too petty and lack power of concentration and the faculty to be wholly absorbed in one thing—

Is this too rash a statement? Perhaps it is—if so I humbly beg women's pardon.[10]

Five years later she mentioned to him that she had been offered work as a photojournalist, but she did not feel "fitted" for it. "... it is man's work ... I am not aggressive enough."[11]

It has also been intimated that Weston gained fame exploiting her as a nude model.[12] His international reputation as a salon-winning pictorial photographer at this time was not, however, due to his work with nudes. As a matter of fact, he photographed only five nude models in his thirty-three months in Mexico. It was not until he was reestablished in California in 1927 that he developed great enthusiasm for this theme.

One biographer wrote that Weston "abandoned" Tina in Mexico. Another stated that he taught her "how it felt to be treated like an object."[13] The twenty-two letters and fragments of letters from her that survive, however, show no signs of resentment. Actually she thanked him profusely.

Going back to photography Edward—you don't know how often the thought comes to me of all I owe to you for having been the one important *being, at a certain time in my life, when I did not know which way to turn, the one and only vital guidance and influence that initiated me in this work that is not only a means of livelihood but a work that I have come to love with real passion and that offers such possibilities of expression (even though I am not making full use of these possibilities). Really Edward dear—my heart goes out to you with such a deep feeling of gratitude and even though I do not mention this to you often I would love you to know how genuine and deep my appreciation is and will always be! And I am sure you believe me! I find myself again and again speaking with friends about this precious work which you have made possible for me—I would so love to see you even a little while and tell you all the things my heart feels toward you.*[14]

These select examples show how grossly one bias, an allegedly feminist one in this case, can and has affected attitudes and information about Modotti.[15] This insensitivity to fact, this tendency to write her biography in the subjunctive tense and to interpret information to support a bias, extends as well to the mechanics of the research and writing that has been done on her.

Modotti's photographs have almost consistently been dealt with as if they were illustrations. Dates, sizes, processes and sources are usually

FIGURE 17:
Jane Reece,
Madame de Richey, 1919.

FIGURE 18:
Jane Reece,
Edward Weston, 1919.

not cited; when they are, they are often incorrect. When dates are supplied, there is only rarely an explanation, and sometimes they do not correspond to the time that Tina was in the place they were taken. In addition, the content of her prints has not always been carefully observed, or, for example, the photograph of a man reading the Communist Party paper *El Machete* would not have been assigned to 1926[16] since the newspaper in the picture is dated "the first week of June 1927." Most researchers do not seem to have questioned the accuracy of material obtained in interviews, even though the events being described took place fifty years earlier. It is a fact that the death of an acquaintance, self-interest and the passage of time tend to soften one's memory and improve a story.

Specific references have been treated in the same non-critical fashion, as if they were an unnecessary distraction to a "good read," as if the act of printing something in ink establishes it as truth, as if the author was confident that the reader would accept anything about Tina on faith.

I believe that Modotti had an individual and very complex style and that her works were not merely a reflection of Weston's. Discussion of her fascinating personal and political involvements, however, does not need to be undertaken at the expense of the conventional art historical analysis that her photography merits. Critics and historians seriously concerned with her photographic work will have to return to primary sources and should not assume that information which is presented as if it were common knowledge is, in fact, accurate.

Weston and Modotti had probably met by 1919, when they and Roubaix de L'Abrie Richey, an artist who was called Robo and who, allegedly, was married to Tina,[17] each had their portraits made by Jane Reece, a pictorial photographer visiting Los Angeles from Dayton, Ohio (figures 17, 18 and 19). Reece had exhibited four times in Los Angeles from 1917 to 1919. Weston apparently gave her five of his finest pictorial prints.[18] Since the number of avant-garde artists in Los Angeles at this time was limited, it is extremely probable that Weston, Modotti and Robo all knew each other. Although Weston attended parties at Robo's studio by 1920, careful reading of pertinent documents suggests that he did not fall in love with her at first sight, as writers consistently maintain. It seems that he did not become "enamoured" of her until early spring 1921, when he apparently spilled sake on her hand and they listened to the Spanish violinist Pablo de Sarasate's "Romance" together.[19]

By this time, Weston had firmly established an international reputation as one of the most respected pictorial photographers. He had, however, almost completely stopped submitting photographs to salons. In fact, he was undergoing a particularly intensive period of self-exploration, bored with regurgitating pictorial formulas he had long since mastered. Modotti had worked as an actress, having minor roles as a femme fatale in at least two movies, *Riding with Death* (1921) and *I Can Explain* (1922). Robo was known for his batik work and often made costumes for her. *Tentación* (*Temptation*, figure 20) is a drawing by him for which she modelled. A comparison of it with a 1924 portrait of her by Weston (plate 5) demonstrates the radically different perceptions of her which the two men enjoyed.

Robo and Edward were, however, close friends, and the three of them planned to move to Mexico together. Robo left for Mexico in early December 1922, and on the 23rd he wrote Weston an extremely enthusiastic letter about "the artists' paradise" he had found and urged him to come soon. He also informed him that Recardo Gómez Robelo, whom Weston had photographed in Los Angeles in 1921, had been promoted to chief of the Department of Fine Arts and had planned an exhibition of their work for January.[20] Robo, however, died on February 9, 1923, and Modotti went to Mexico City to bury him. On that occasion she met several of the muralists, saw their work, showed them Weston's photographs and investigated the artistic environment. Weston commented, "Tina wrote me the exhibit [was] a great success in Mexico—'already many of your prints have been sold'—'A prophet is not without honor' etc.—I think I have sold two prints in the many years I've exhibited in the U.S."[21]

On July 30, after many postponements, Edward and Tina, along with Weston's eldest son, Chandler, finally sailed for Mexico, leaving in Tropico Weston's three other sons and his wife Flora. Within a few days of their arrival, she introduced Weston to the painter Diego Rivera, and they met with Xavier Guerrero, whose portrait Weston had made in Los Angeles the year before. She also arranged an exhibition of his photographs at the Aztec Land Gallery for the second half of October. "She is invaluable—I could do nothing alone," Weston wrote.[22]

It is not known when Modotti actually became interested in photography and started taking pictures herself. It should be pointed out, however, that her father's brother, Pietro Modotti, was a photographer who was comfortably established in Udine, Italy, her

FIGURE 19:
Jane Reece,
Son of Man (Posed for by Roubaix de Richey), 1919.

FIGURE 20:
Roubaix de L'Arbrie Richey,
Tentación (Temptation), before February 1922, from *El Universal Ilustrado*.

FIGURE 21:
Edward Weston,
Circus Tent, 1924.

birthplace, during the first decades of the century.[23] She had also probably watched Weston's studio when he went away for a few days in April 1923, during which time she was with photographer Johan Hagemeyer in the darkroom and went with him on an assignment. We also know that she accompanied Weston, Margrethe Mather—the photographer with whom Edward shared his studio—and Hagemeyer on a photographic outing to the tile factory on April 15, 1923.[24] So far, however, there is no hard evidence to prove that Modotti had ever been on anything other than the receiving end of a camera before she went to Mexico with Weston in 1923.

She did, however, go there with the intention of learning to be a photographer. In December 1923 Weston stated, "I shall fulfill my part of the contract and teach Tina photography."[25] Then, in February 1924, he wrote to Flora, "She wants to learn photography and is doing well—she has no wish to return to the stage, and photography would make her to some extent independent."[26]

While in Mexico, Weston used an 8-by-10-inch Seneca folding-bed view camera as well as a 3¼-by-4¼-inch Graflex camera that he also shared with his "apprentice," Tina, and his sons. Tina's main camera in 1923 and 1924 was a 4-by-5-inch Korona, a basic view camera that Weston probably gave her. When she was in San Francisco in early 1926, she purchased a 3¼-by-4¼-inch Graflex, equipped like Weston's with a $f/4.5$ Tessar lens and two magazines. She sought out the Graflex to help her "loosen up," and she wanted it enough that she was willing to sell her Korona. It seems that she did not part with it, however, since the painter Jean Charlot referred to it when he described her work photographing murals in 1928. Moreover, the Mexican photographer Manuel Alvarez Bravo said that she left a camera with him in 1930, when she was expelled from Mexico—and in her letters from Germany and the Soviet Union in 1930 and 1931, she mentioned having the Graflex with her.[27]

On February 27, 1924, Weston mentioned in a letter to Hagemeyer how pleased he was with Tina's work, and in the same letter she enclosed a photograph of a puppet that she had probably taken. This would be the earliest photograph by her that can be identified.[28] The first specific reference to her actually taking pictures, however, occurred in an entry in the *Daybooks* on March 3, 1924. On March 1, they had gone with friends to the Russian Circus. Then, the next morning, the two of them returned to photograph.

A recent morning I took my Graflex to the circus, made negatives which pleased me of the graceful folds, the poles and ropes of the tent. One, "shooting" straight up, recalls a giant butterfly. At least two of them are interesting as experiments in abstract design. Tina too made several good things of the circus.

Weston described his picture (figure 21) and his *Stairwell of the Colegio de San Pedro y San Pablo*, taken at about the same time, as "pleasant and beautiful abstractions, intellectual juggleries." He later commented that he would have preferred a "more searching, critical definition" but that he made a "good print," one that was "visually satisfactory." Jean Charlot and Diego Rivera both listed it as among their favorite prints by him, and he exhibited it several times and maintained it in his collection of active prints until at least 1945.[29]

Four images by Weston of the circus tent have survived, three of them only as negatives.[30] The one that he chose to print is the one in which the forms are the simplest and the directional movement the clearest. A single white wedge rises undeterred, diminishing continuously in size, until it reaches a point on the upper edge of the picture. Unlike two of the other images, no people were included in this composition so that the forms are extremely abstract and the space and scale are completely denied.

Modotti's interpretation of the same place—at the same time, in the same light and very possibly with the same camera—reveals another personality, that of an artist whose style is clearly distinguishable from Weston's (figure 22). In her composition, she included the walls of the tent, as well as the roof and its shadows. She also showed the bleachers and four seated spectators. By doing this, she established the existing space clearly, then offset it by means of the black, snake-like seam that appears to dangle in an undefined space from the upper right to the middle right of the picture plane.

As early as March 1924, Modotti included people—strangers—in her pictures. She may have felt that they gave the composition a sense of specificity and helped locate it in time and space; she certainly did not learn this from Weston. Weston was incapable of being a street photographer. In his *Casa de Vecinidad* series he printed the negatives that were the most synthesized and that were also the ones in which people were the least noticeable. One can imagine him waiting until they finally moved off his ground glass completely or into an appropriate place, such as a deep shadow. Tina, however, readily included them in her

FIGURE 22:
Tina Modotti,
Tent, Mexico, 1924.

compositions. This seems to suggest that she felt more comfortable with strangers than he did, and possibly that she even felt an affinity for people on the streets, which could be seen as consistent with her later association with the Communist Party.

A few of her prints were considerably more radical and experimental than anything that has survived by her teacher. This is perhaps partly due to the fact that she had not been carefully following developments in modern art and pictorial photography for twenty years, as he had been. As early as 1924 she presented a paper negative as the final print. One of her later compositions consisted of a blurred crowd seen from above, as if all the people were moving. She incorporated political symbols in a few of her photographs with the same impact and intensity with which religious symbols were commonly found in *retablos* and popular art. By 1926 she was recording details of everyday objects such as flowers, stairs and glasses in a monumental way, abstracting them and seeing them as uncomplicated and pure forms.

Both Tina and Edward photographed popular art. These compositions are usually referred to as still lifes, a genre in which arranging the objects is an important part of the finished work. Although it was not until Weston reached Mexico that he became involved with this kind of subject matter for the first time, it would play an extremely important role in the second half of his career.

FIGURE 23:
Tina Modotti,
Painted Papier-Mâché Toys, 1924-1926.

Modotti's *Painted Papier-Mâché Toys* (figure 23) is undated, but it had to have been made before November 1926, since it was included in a large assignment completed then.[31] She placed the dolls on a white marble table top and in front of a clean white wall so they would stand out clearly. Most of the toys, the *juguetes*, cast delicate shadows against the wall that do not distract from the overall high key of the picture.

FIGURE 24:
Edward Weston,
Petate Soldiers, 1926.

Weston, on the other hand, in his *Petate Soldiers* (figure 24), chose to photograph in a very strong natural light so that the shadows from the toys became an important part of the composition, in effect repeating the horizontal line on the back wall. He placed his woven reed dolls in front of a rough adobe wall so that they would seem to be in an appropriate, natural setting. Both photographers have denied a sense of scale to their compositions, although the central horseman, the Pancho Villa in Weston's picture, is about fifteen inches high; the charro, the man on horseback in Modotti's, is about two inches high.

The most significant difference between the two pictures is the mood

they convey. This, of course, reflects the attitudes of the photographers towards their work and towards the toys at that moment. Modotti created an orderly and symmetrical parade of static figures, each group carefully separated from the next, each listening for the right beat in the military music, or maybe stopped, waiting for marching instructions. Weston, however, avoided anything that resembled regimentation and chose to depict the chaotic behavior of the spectators at the parade. The right part of his composition shows the Pancho Villa-figure saluting the unseen, approaching celebrities and the two standing men blowing their bugles to welcome them. On the left side, two women ignore the festivities and chatter away. The spacing between the figures suggests that they just naturally fell that way, not that they were methodically placed or that any serious thought went into this ridiculous scene.

Weston described this picture as "amusing" and made it for the pure joy of doing it, not because of an assignment. It shows that he enjoyed his work, that the toys made him laugh. He commented, "I have made the *juguetes*, by well considered contiguity, come to life, or I have more clearly revealed their livingness."[32]

This "living" quality is also characteristic of Weston's most exciting portraits, which tend to be of his closest friends, like Jean Charlot (figure 25). He seems to have needed a certain degree of intellectual or spiritual intimacy with the subject in order to be able to recognize something about the vital essence of that person. This is shown here by the assertiveness of Charlot's body language, which contrasts with the contemplative quality seen in his eyes. Certainly Weston would have needed to know his subject and to observe him in different moods and situations in order to predict his behavior and be able to trigger his shutter on time, rather than after what he wanted had gone by. Weston's most interesting portraits consist of instants or segments, not poses. By the time he took Charlot's portrait on November 5, 1926, he had some fifteen years of experience in the field of portraiture and had been closely associated with Charlot for three years. He seems usually to have focused on the eyes, which he must have considered the most expressive feature, and, in men, he accentuated the line of the upwardly lifted jaw. He used slightly uneven light to show contrast between volume and texture and to create a visual energy.

On the other hand, in the portrait of Charlot attributed to Modotti,[33] she has shown the sensitive, poetic side of his personality (figure 26). His

FIGURE 25:
Edward Weston,
Jean Charlot, 1926.

eyes are raised, his chin lowered; she has shown a vulnerable boy posing, rather than an assertive man. In order not to distract from his features, she photographed him against a dark background and focused on the linear quality of his profile. She used a softer, flatter, conventionally more becoming light than did Weston. As a result, she obtained a traditional pictorial effect that seems to have emerged from a studio, rather than one that superficially appears to be a lucky shot, like Weston's. The fact the Modotti and Charlot were friends and spent a great deal of time together does not seem to be reflected in this picture; in other words, it is not an exceptionally personal statement of either of the artists involved.

People who are familiar with Tina Modotti's style might disagree with the relevance of this last analysis on the basis of the portrait frequently attributed to her of Edward Weston with his 8-by-10-inch Seneca view camera (figure 27).[34] No evidence exists to justify this attribution, however. Stylistically it appears to be by Weston, closely related to the "heroic heads" he made of Hernández Galvan, Nahui Olin, Lupe Marín de Rivera, Ricard Gómez Robelo, Karl Struss, Xavier Guerrero and O. G. Jones, as well as that of Jean Charlot. The style, composition and spirit of this work, however, do not correspond with Tina's way of seeing.

The focus is on the lens and on the whites of Weston's eyes. The portrait is taken from below, so that the strong jaw-line is again emphasized. The extended bellows on the camera enhance the impression of depth and three-dimensionality. The contrast of the different textures, of the glass of the lens, the wood and metal on the camera frame, the coarse linen of his shirt and the shininess of his nose emphasize the energy present and visible in the sitter. The intense and fixed focus of his eyes and the aggressive sense of his body language—the tense muscles in his neck and shoulder—are, I believe, not found anywhere in Modotti's work but are found frequently in Weston's portraits.

There is another picture, however, taken within a few minutes of this one, that may well be completely conceived and produced by Modotti. It consists of a three-quarter-length view of Weston in the same clothes, relaxed, standing a little bit away from his Seneca and looking away from the photographer behind the Graflex.[35] Five prints of this portrait of Weston have been located; none of them is signed or dated by either photographer. Allegedly another print exists which says "Tina" on the

back, but this could also mean that the print in question belonged to Tina. Edward gave a copy of this picture to his close friend Monna Alfau de Salas, and she recalled that he referred to it then as his "Self-portrait,"[36] as did his second wife, Charis Wilson.

Critics may complain that this comparative analysis of Weston's and Modotti's work has been based on too few samples, that not enough photographs have been illustrated, that none of the standard works has been included. On the last two points they would certainly be correct; the old-time favorites are, however, readily available in other publications. As for the first point, I would like to emphasize that the photographs illustrated were chosen with great care, and stylistic generalizations made on the basis of these few comparisons take into consideration other work by these artists.

Obviously Weston was much more productive than Modotti, but he had been practicing for a much longer period of time and never questioned the fact that this was and would be his career. He frequently acknowledged the many ways Tina assisted him; and she, along with his sons Chandler and Brett, were the only photographers in Mexico whose work he respected and found stimulating.

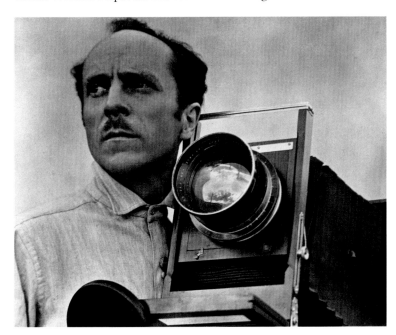

FIGURE 27:
Edward Weston,
Self Portrait with 8-by-10-inch Seneca View Camera, Mexico, 1923-1926.

What Tina shared with or learned from Edward basically consisted of photographic technique, as well as the ability to be straightforward and to recognize and respect simple forms, or, in the terms of the time, "significant form." In the one article Tina wrote, "On Photography," which was composed and printed on the occasion of her December 1929 show sponsored by the University of Mexico, she borrowed key words, phrases and concepts from statements made by Weston.[37] She explained that she tried to make photographs "without distortions or manipulations," that photography should not imitate "other mediums of graphic expression" and that it had to accept "all the limitations inherent in photographic technique and take advantage of the possibilities and characteristics the medium offers."

She disagreed with Weston on only one point, which is the subject of her last paragraph.

Photography, precisely because it can only be produced in the present and because it is based on what exists objectively before the camera, takes its place as the most satisfactory medium for registering objective life in all its aspects, and from this comes its documental value. If to this is added sensibility and understanding and, above all, a clear orientation as to the place it should have in the field of historical development, I believe that the result is something worthy of a place in social production to which we should all contribute.

By that time Weston had stated that "photographic beauty" was an attempt to present "objectively the texture, rhythm, form in nature without subterfuge or evasion in technique or spirit."[38] He never intended, however, to apply this to "life in all its aspects" or to photography's "place in social production." Modotti's view is consistent with the ideology of the Communist Party that she had espoused since at least 1927.

Her photographs were, in fact, significantly more objective than Weston's. She did not seem to depend as heavily as he did on personal involvement or emotional reaction and usually avoided invading people's thoughts and feelings. It is a logical extension of this that she often used a softer and flatter light that revealed considerably less volume and texture and emphasized linear qualities. Even in many of her earliest works, she clearly articulated space and time as a documentary photographer might. Her pictures of Mexican workers and symbols of the Communist Party, most of which were probably

taken after Weston left, justify the use of the word "political" to refer to some of her photographs.

A good part of Weston's work in Mexico was also political, although in another way. It was not his style to join any organized group with a fixed ideology—even the *f/64* movement—but to describe the objects he photographed as "socially neutral" only indicates a lack of awareness of the cultural situation in Mexico then and of his emotional and aesthetic attachment to Mexico.[39] It seems that, to a certain extent, the objects he photographed symbolized Mexico and the Mexican people for him, since he usually described both in fond and affectionate terms. One of the more significant results of the Mexican Revolution was a generalized program to promote the concept of national pride—that Mexicans could and should be proud of being Mexican, that the finer things did not have to be imported, that the Virgin did not have to be blond, that their own indigenous roots and accomplishments were not only healthy and beautiful but also theirs. While he was in Mexico, Weston focussed on many subjects that were symbols of non-colonial Mexican culture, even at the risk of being picturesque. In doing so, he emphasized the fact that, for him, they were objects of striking beauty and worthy of admiration. He recognized and appreciated the identity and aesthetic integrity of these subjects, but he did not allow the object to dominate his composition, or the result would have been illustrative. Nor, however, did Weston allow his own style to dominate, or the outcome would have appeared patronizing and exploitive. Instead, he found a balance between these two traditional approaches.

Upon studying Weston's portrait of Senator Manuel Hernández Galvan, Diego Rivera—a member of the Communist Party and perhaps the most visibly nationalist of all the muralists—stated, "Es un retrato—portrait—of Mexico."[40] This attitude of Weston's about Mexico, reflected so clearly in his photography, certainly impressed Modotti as it did the Mexicans. In evaluating their relationship, "the fineness of our association," as he wrote,[41] it should be kept in mind that Tina's sense of adventure and her outgoing personality countered Weston's slightly reclusive tendencies. Without her support and companionship, he would not have gone to Mexico and would never have been exposed to and consequently excited and refreshed by Mexican culture. This contact profoundly influenced his thought then and gave new directions and values to his photographic work.

NOTES

1. Robert d'Attilio, "Glittering Traces of Tina Modotti," *Views* 6, Summer 1985, 7.

2. Anita Brenner quoted by David Vestal, "Tina's Trajectory," *Infinity* 15, February 1966, 6.

3. D'Attilio may have been referring to the fact that Weston once praised a photograph by Modotti by saying that he would have been happy to have done it. He showed his admiration for another by stating that he would be willing to sign it. He spoke this way fairly often, not just about an occasional picture by Modotti, but also about work by Chandler Weston, by Sonya Noskowiak and by others. This is by no means, however, the same as saying that he could have done it or that their works were sometimes "indistinguishable." I know of no other statements by Weston that could be understood or misunderstood in this manner. (Edward Weston to Johan Hagemeyer, February 27, 1924; [All correspondence cited is in the collection of the Center for Creative Photography, Tucson, Arizona, (hereafter CCP) unless stated otherwise.] Edward Weston, Nancy Newhall, ed., *The Daybooks, Vol. I: Mexico* [Millerton, N.Y.: Aperture, 1973], 31-32, 69 [hereafter cited as *DB I*]. Edward Weston, Nancy Newhall, ed., *The Daybooks, Vol. II: California* [Millerton, N.Y.: Aperture, 1973], 141 [hereafter cited as *DB II*]).

 In 1926 Anita Brenner contracted Weston and an assistant to make 400 photographs of popular art for what was to be her book, *Idols Behind Altars*. These images as well as the annotations on many of them, the *Daybooks*, Brenner's journal, their contract, the twenty-eight letters and postcards from Weston to Brenner, and letter credit lines and acknowledgments (except for Brenner's) all support the thesis that Modotti made virtually no photographs on the trip they took to make these pictures. Brett Weston accompanied them and he also recalled that she did not make any photographs. Of those eventually published, a few were made by Modotti in Mexico City. (Amy Conger, Edward Weston in Mexico: 1923-1926 [Albuquerque: University of New Mexico Press, 1983], 47-51.)

4. Diego Rivera, "Edward Weston and Tina Modotti," *Mexican Folkways 2*, April-May 1926, translation, Beaumont Newhall and Amy Conger, ed., *Edward Weston Omnibus* (Salt Lake City: Peregrine Smith Books, 1984), 21-22.

5. No copy-work has been included in these figures since, by definition, it does not allow a photographer to express his or her personality. The total for Modotti was arrived at by comparing the holdings of major public collections, inventories of private collections and offerings in auction catalogues, as well as from publications on her. Vintage prints of all 160 by her do not exist. The photographs by Weston are catalogued and discussed in Amy Conger, "Edward Weston's Early Photography, 1903-1926," Ph.D. dissertation, University of New Mexico, 1982.

6. There are no indications that Modotti kept a diary or a negative log. Except for her correspondence with Weston, letters written to her or by her are rare. One could also wonder why she did not obtain either a U.S. passport, (since she resided in the United States for 10 years) or a Mexican one, since she seemed fairly happy there. It would be interesting, however, to know what motivated her to write a will in December 1924 in which she left everything to Weston (CCP).

 The Italian Police records do not list either her name or birthdate correctly. Other sources do not agree on even her birthdate or death date.

7. Laura Mulvey and Peter Wollen, "Frida Kahlo and Tina Modotti," *Frida Kahlo and Tina Modotti* (London: Whitechapel Art Gallery, 1982), 10.

8. Mulvey and Wollen, 12.

9. Weston, DB I, 58.

10. Modotti to Weston, July 7, 1925.

11. Modotti to Weston, May 23, 1930.

12. Mulvey and Wollen, 22 and 26.

13. Mildred Constantine, *Tina Modotti: A Fragile Life* (N.Y.: Rizzoli, 1983), 21; Linda Andre, "Body Language: Frida Kahlo and Tina Modotti," *Exposure 22,* Summer 1984, 27.

14. Modotti to Weston, very late 1927 or early 1928 (quoted by Weston in DB II, 43).

15. Nor have I located any information to support the following statement: "It was a difficult relationship, marked for Weston . . . above all by the visceral, American anti-communism that slowly created an insurmountable barrier in his relatinship with Tina . . ." (Maria Caronia and Vittorio Vidali, *Tina Modotti Photographs*, trans., C. H. Evans [New York: Idea Editions of Belmar Books, 1981], 16.) On the contrary, some of his best friends were Communists, and he followed their cultural accomplishments with interest. (See Edward Weston to Flora Weston, March 29, 1924.)

16. *Frida Kahlo/Tina Modotti* (Mexico City: Instituto Nacional de Bellas Artes, 1983), 62 and 113.

17. The assumption that Tina and Robo were married may be false since Tina told Edward that this had never actually occurred. (Nancy Newhall, notes dated August 30, 1965, Collection of Beaumont Newhall, Santa Fe, N.M.)

18. Karen S. Chambers, "Jane Reece: A Photographer's View of the Artist," M.A. thesis, University of Cincinnati, 1977, 162 and 164. Amy Conger, Ph.D. dissertation, part II, 112-13, 135-36, 163, 182-83 and 235.

19. Weston to Hagemeyer, July 18, 1921; Weston, DB II, 134 and 154; Modotti to Weston, January 27, 1922.

20. This exhibition also included works by Robo, Margrethe Mather, Jane Reece, Arnold Schroder (who also did portraits of Modotti illustrated in Constantine [1983, 34-35]), and two unknown artists. (Rafael Vera de Cordova, "Las fotografias como verdadero arte," *El Universal Ilustrado*, March 23, 1922, reprinted and translated in Newhall and Conger, 13-16.)

21. Weston to Hagemeyer, undated (Spring 1922).

22. Edward Weston to Flora Weston, September 1, 1923.

23. Conversation with Yolanda Magrini (Tina's sister), July 29, 1985; d'Attilio, 9.

24. Hagemeyer's diary, April 15 and April 17, 1923 (CCP). Hagemeyer also made a snapshot of this outing; prints of which are at the Center for Creative Photography and the George Eastman House.

25. Weston to Ramiel McGehee, December 14, 1923.

26. Edward Weston to Flora Weston, February 22, 1924; he practically repeated himself in another letter to her dated April 22, 1924.

27. Weston to Hagemeyer, October 15, 1924; Modotti to Weston, January 23, 1926 and January 25, 1926. (This is probably the camera illustrated in *Camera Craft 30* [May 1923], n.p.) Jean Charlot, "Foreword," in Jose Clemente Orozco, *The Artist in New Year* (Austin: University of Texas Press, 1974), 18. Interview with Manuel Alvarez Bravo, May 7, 1979, Tucson.

 Although when she first arrived in Germany, Modotti did not like the miniature cameras, after awhile she tried to sell her Graflex in order to buy one (Modotti to Weston, May 23, 1930 and January 12, 1931).

28. Modotti to Hagemeyer, February 28, 1924; the photograph is located at the Center for Creative Photography. Modotti also soon began to exhibit. On November 1, 1924 Weston and she exhibited at the Palacio de Mineria and took first and second prizes in photography—not surprising since Diego Rivera was on the jury. They also exhibited together at the State Museum of Guadalajara in August–September 1925. (See Siqueiros' review in Newhall and Conger, 19-20). In September 1928 she participated in another group exhibition; in December 1929 she had her first show alone, sponsored by the University of Mexico. In 1930 she had a photograph included in an exhibition at the Harvard Society for Contemporary Art.

29. Weston, DB I, 52-53, 55, 59, 98, and 109; Amy Conger, Ph.D dissertation, part II, 493-94.

30. Weston donated the print to The Oakland Museum. Three negatives, all 3¼ by 4¼ inches are at the CCP.

31. A cropped version, credited to Tina Modotti, was published in Justino Fernandez, *El arte moderno en Mexico* (Mexico City: Antiqua Libreria Robredo—Jose Porrua Hijos, 1937), figure 238.

32. Weston, DB I, 150.

33. This photograph is neither signed nor dated. Charlot inscribed it to a friend who recalled that it was by Modotti. Since other statements by this person about specific photographs have proved accurate and since the style corresponds with signed portraits of Stanislas Pestkovsky and Antonio Mella, it seems reasonable to attribute it to Modotti.

34. This attribution seems to have originated in Mildred Constantine, *Tina Modotti: A Fragile Life* (N.Y.: Paddington Press, 1975), 104.

35. The only print of this which has been located is in Flora Weston's album, now in the possession of the Weston family.

36. The Weston Gallery in Carmel owns the only enlarged print that has been located. The other four are contact prints (approx. 3 by 4 inches). One which

was originally the property of Brett Weston is now located at the Amon Carter Museum in Fort Worth, Texas. Another is in the album which belonged to Flora Weston. The third was offered at the Butterfield & Butterfield auction on September 19, 1984 and the last is in a private collection.

37. *Mexican Folkways* 5, October-December 1929, 196-198; *Kahlo/Modotti*, 99. Almost certainly Tina had copies of the following five articles by Weston, all of which are quite similar. They include "Photography," 1926, 45; "Statement," 1927, 46; "Concepts of the Artists," 1928, 47; "From My Day Book," 1928, 48-52; and "America and Photography," 1929, 55; all of which are reprinted in *Edward Weston on Photography*, Peter C. Bunnell, ed., (Salt Lake City: Peregrine Smith Books, 1983).

38. Weston, "From My Day Book," 51.

39. Mulvey and Wollen, 22.

40. Weston, DB I, 105.

41. Weston DB I, 50.

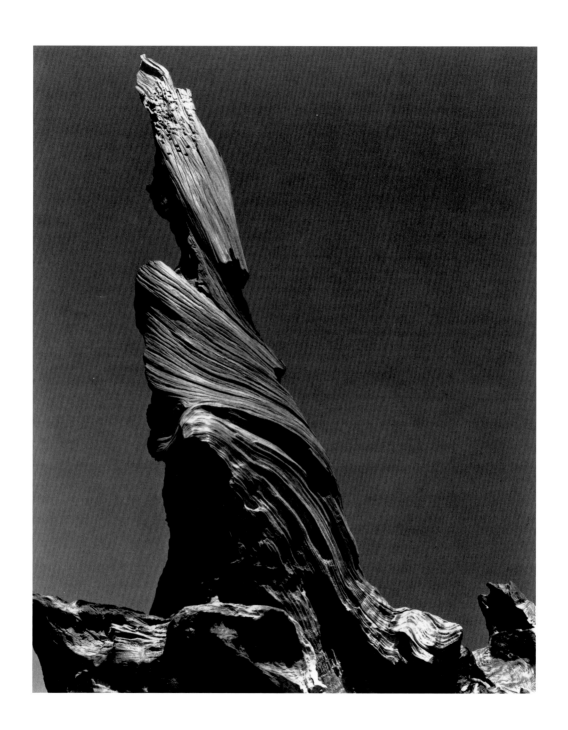

BY MIKE WEAVER

EVER SINCE IT BECAME FASHIONABLE TO DENOUNCE THE *Family of Man* exhibition as a manifestation of Cold War ideology, Edward Steichen has suffered serious neglect, as if his undoubted commitment to bourgeois capitalism precluded him from further critical consideration. There is no branch of photography that has not benefited from his extraordinary talent, yet his influence on Edward Weston has been overlooked. For more than twenty years, however, we have had available to us, in Steichen's own autobiography, a thousand-word essay on the metamorphic possibilities of photography, an essay that is indispensable to an understanding of the morphological aspects of Weston's work. Together, Steichen and Weston were responsible for the American contribution to the *Film und Foto* exhibition in Stuttgart of 1929, and neither of them, it turns out, needed any connection with Karl Blossfeldt, the German art teacher who photographed magnified plants, to validate their own long-standing interest in the aesthetic and symbolic possibilities of natural forms. The amateur scientist and aesthetician Theodore Andrea Cook (1868-1927), following the great English tradition of morphological studies that began with the Darwins, had noticed the relation between a bishop's crozier in New College, Oxford, and "the beautiful little flat spiral of a fern frond gradually uncurling,"[1] many years before Walter Benjamin saw it demonstrated in Blossfeldt's *Urformen der Natur* (1928). In fact, Steichen had been studying Cook's work since at least 1919, if not earlier. Around that time he began a three-year study of ratio and proportion in art, with reference to the structure of organic forms.

For many years I had been impressed by the beauty of the spiral shell on the snails so abundant in our own garden. . . . I found some form of the spiral in most succulent plants and in certain flowers, particularly in the seed pods of the sunflower, of which I had made so many photographic studies. . . . I decided there must be a relationship between all these things and what had been known for a long time as the Golden Section.[2]

In order to advance the intuitive powers of artistic insight over intellectual understanding, Steichen was careful to suggest that the pictures were made first; but he was honest enough to admit that the Modernist movement that he had himself introduced into the Stieglitz circle had left him, a Symbolist, out on a limb after the Great War. He needed a new intellectual basis as a discipline for new work.

PLATE 6, OPPOSITE:
Edward Weston,
Driftwood Stump, 1937.

Finally I found a book written in 1914 by Theodore Andrea Cook, THE CURVES
OF LIFE, BEING AN ACCOUNT OF SPIRAL FORMATIONS AND THEIR APPLICA-
TIONS TO GROWTH IN NATURE. *This book not only confirmed the vague
findings I had struggled so hard to determine, but also covered things I had never
dreamed of. . . . From that time on I began to feel sure that, one day, scientists
would discover that the shape of the universe was the logarithmic spiral. If only I
had found his book earlier, Cook's detailed scientific investigations could have
saved me months of laborious study and calculation.*[3]

But Steichen could, and should, have known of Cook since 1903, when
the first, small version of the great work *Spirals in Nature and Art* was
published. As editor of the sporting magazine *The Field*, and author of
the definitive four-volume *History of the English Turf* (1901), Cook's
name would have been familiar to Stieglitz, whose only serious passion
in life, after photography, was horse racing. Furthermore, Cook was
the close collaborator of Frederick Evans, the English photographer
who not only provided the illustrations for Cook's *Twenty-Five Great
Houses of France* but supplied many illustrations for *The Curves of Life*.
As Anne Hammond has shown,[4] Evans' interests in photomicrography,
pendulum drawings and the interiors of Gothic cathedrals as overlapped
planes of arched ribs were closely related to Cook's ideas. Interestingly,
Evans was the one British photographer to whom Weston himself
related.[5]

How Weston learned of Steichen's efforts is not clear. Johan
Hagemeyer may have been the go-between, but that is not firmly
established.[6] Hagemeyer, the former California nurseryman, and
Steichen, already a breeder of delphiniums, had botany in common.
Certainly, Hagemeyer's own interest in photography was immensely
stimulated by Stieglitz, and perhaps even by Steichen, in this critically
formative period of around 1916. It was Hagemeyer, though, who
opened up a new intellectual world to Weston after 1920. In Mexico the
renaissance mural painters were trying to solve the pictorial crisis with
the help of their intellectual leader, Jean Charlot, who, by 1927 at the
latest, was committed to Cookian ideas through the work of Matila
Costiescu Ghyka, the Rumanian aesthetician (1881–1965). Charlot
emphasized the two-way nature of the relations between Weston and the
muralists. The problem of uniting nature with an aesthetic approach
was the problem shared by both.

Looking at these photographs cleansed objectivity of its Victorian connotations. The problem of geometric bulk that the Mexican muralists had worked on, under the spell of Cubism and Aztec carvings, appeared superficial compared to Weston's approach. He dealt with problems of substance, weight, tactile surfaces and biological thrusts which laid bare the roots of Mexican culture.[7]

What Charlot had to offer Weston was a world art-consciousness that had helped him out of the pictorial impasse of the previous years. A photograph like *The Hand of Amado Galvan* (1926)[8] lacks the subjectivity of art, asserts the validity of physical action and perplexes at the same time. The pot spirals upward, notionally right-handedly. But the hand that grasps it firmly is a left hand, not twisting naturally to its left but to its right. The tension is extreme, as can be seen in the wrist. This was what Mexico did for Weston: "It was in front of a round smooth palm tree trunk in Cuernavaca that he realized the clean elegance of northern factory chimneys."[9]

In 1927 the Rumanian Ghyka, who wrote in French, published *L'Esthètique des proportions dans la nature et dans les arts*. Charlot read it when it came out, and when it appeared in an English translation as *The Geometry of Art and Life* (1946) he reviewed it.

I remember with what surprise I discovered that the sunflower—made by Van Gogh into a kind of expressionistic soul-mirror and rejected as impossibly romantic by the Cubists—grows along a pattern of logarithmic spiral. To learn that the decreasing size ratio of the vertebrae of the neck of a swan can be interpreted mathematically made us humble, as it suggested that the foundation of beauty, even postcard beauty, went deep into this Pythagorean realm of numbers at whose threshold we stood, Ghyka's book in hand and a duncecap securely screwed over our Bohemian wigs.[10]

Ghyka's work is heavily indebted to Cook on the one hand, and to Jay Hambidge, the Yale geometrician whose *Dynamic Symmetry* (1920) influenced scores of American artists, on the other. Interestingly, when Hambidge died in 1928, his widow wanted Orozco, the muralist, to continue his work,[11] so the involvement of the Mexicans with Hambidge's attempt to provide a rationale for the contemporary artist is established. But, of course, Steichen had been there before them.

The revelation of Cook's writings on spiral formations was still upon me when my friend Arthur Carles, who knew of the work I was doing, sent me copies of a

magazine called THE DIAGONAL, *written and edited entirely by Jay Hambidge and published by the Yale University Press. Hambidge had worked out the problem of the "section" in a geometric form in which he used a square to produce a sense of rectangles. One rectangle was in mean and extreme ratio, the others built upon it were a series of root rectangles.*[12]

What Steichen referred to was the Golden Section, in which a series of rectangles within an all-embracing one could be added or subtracted to set up pleasing proportional relations.

Weston's *Church Door, Hornitos* (1940)[13] depicts an inner series of rectangles in such a way as to invite several combinations. The door-jamb demarcates, vertically, an area to its right that is approximately one-third of the whole image, while the board at the center of the door itself permits other rectangles to be formed, horizontally as well as vertically. Above all, the shadow is fixed in such a position as to be equal to the horizontal boarding on the other side of the doorjamb; it introduces a magical permutation to the dance of the rectangles.

To be able to perceive what had previously been, in Cook's terms, "unseen," was a wonderful encouragement to the artist. Steichen wrote, "I discovered that everything growing outdoors had become exceptionally alive to me,"[14] and Charlot said, "To the student, emotion and geometry seem at first incompatible; yet they are but two facets of the one art."[15]

The period of Weston's best work, 1920 to 1940, saw a brief set of experiments with the diagonal in the context of portraiture, but Hambidge's system of coordinates in Weston's work rapidly gave way to Cook's spirality. The possibility of ever-expanding growth in the imperfect circle-as-spiral offered a more dynamic model than the square. The spirals of an *Abstract Serpent Head* (1926)[16] were preferable to the cubes of other Aztec sculpture. The idea of Perfect Growth combined well with Charlot's interpretation of Cézanne's "concentric vision." To view the world concentrically was to view it optically, as impersonally as possible. Charlot explained that the artist with concentric vision confronted the world directly.

The world he discovers from his ambush is conditioned by the elasticity of the eye-lens and the varying length of the visual ray. With each given focus he finds himself at the core of a hollowed sphere with a range of visibility coinciding with its periphery. . . . Concentric vision produces a taste for spherical forms.[17]

In Charlot it produced a taste for the circular painting, and in Weston a kind of funnel vision by which he centered objects in a diminishing reflective core of tin. That concentric vision and spirality are connected in human perception is suggested by the remarkable diagram, in Cook's book, of a series of perfect concentric circles which, when placed on a checked background, appear to be a right-handed spiral.[18]

If normal perception can be so subverted by background to introduce movement, it can also be altered to change scale. Once again, however, Steichen had been there before Weston.

One of my experiments has become a sort of legend. It consisted of photographing a white cup and saucer placed on a graduated scale of tones from pure white through light and dark greys to black velvet."[19]

Steichen made a tent of blankets, placed the object within and blocked off all direct light, allowing only a tiny amount of light to be reflected from one side of the covering blanket. His photographs of shells, apples and pears are as obscured as Weston's are luminous, but an effect common to both their work is the subversion of scale. Steichen called one of his images *An Apple, a Boulder, a Mountain* (ca. 1921).[20] It was not only scale that was altered; recognition of the object was also perverted. Steichen's *Three Pears and an Apple* (ca. 1921)[21] is as vulviform in its nature as Weston's *Shells* (1927)[22], in which the perineum is formed by interlocking two shells as one. Charlot wrote an excellent corrective against this kind of anthropomorphism:

The Viennese haze that settles between the Surrealist's eye and the world, by bringing its diversity to a shameful common denominator, disintegrates actual objects and people to such a degree that painting them becomes an artificial exercise.[23]

But although Weston also protested at the intrusion of a shameful, Freudian interpretation of his work, his protests were unwarranted. The *Daybooks* are full of descriptions of objects in metaphorical terms—a squash is a Brancusi sculpture; cypress roots, flames; a shell, a magnolia blossom opening. The whole point of making the images was to transform the objects, and to Weston a bird's feather could be compared to a ploughed field just as Ruskin could compare it, inverted, to the curve of glacial moraine! All Charlot and Weston were rejecting was a vulgar, Freudian reductionism. They wanted us to see the object in an

imaginative space between the literal and symbolic, the actual and typical, the particular and universal. Weston called this approach "significant representation," or "elemental expression."[24]

Early in 1927 Weston met the painter and photographer Henrietta Shore, just a short while before he met his finest model, Bertha Wardell. If they were not the most important women in his personal life, they were certainly the most influential on his work. In Mexico, Shore had met Charlot, who made a lithographic portrait of her for a book of her work published in 1933.[25] Weston was impressed by a nude self-portrait by Shore, and it is possible that it, or another like it in her book, with all the spirality of a Steichen shell, influenced him to photograph Wardell as if he were making charcoal drawings. Shore's trees were like Stieglitz' embracing limbs;[26] her rocks and her clam shell close to Weston's intentions.

Charlot defended her against charges of "anthropomorphic delusion," but Weston criticized her for it.[27] In turn, Charlot preferred Weston's studies of legs to the famous shells because he recognized the shells as unavoidably symbolic. With his knowledge of European iconography, Charlot knew that the chambered nautilus was not simply the nearest form in nature to a logarithmic spiral, but that it also carried overtones of the nautilus cup common in Dutch still-life painting of the

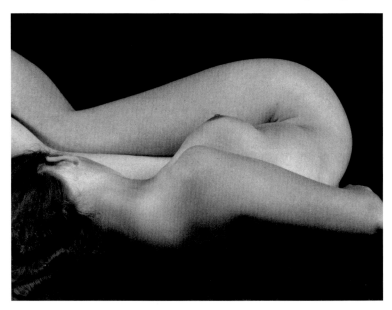

FIGURE 28:
Edward Weston,
Nude, 1934.

seventeenth century, a chalice of Eucharistic significance as well as a rarity in a collector's cabinet.[28] As a Catholic, Charlot found the sexual symbolism of the shell not so much perverse as, perhaps, blasphemous. That Weston was possibly aware that a shell could be used iconographically as a *memento mori* may be seen in his *Cemetery, New Orleans* (1941).[29]

Steichen's *Burtoa nilotica* and Weston's *Nautilus pompilius* are featured on adjacent pages in Cook's book in the classic chapter "Flat Spirals in Shells." When we compare the alignments of the two shells in Cook's illustrations with two famous images by Steichen and Weston,[30] however, we notice that Steichen offers his upside down and Weston not only upside down but laterally reversed. That is to say, while Cook offers a right-hand spiral, Weston offers a left-hand spiral. But right- and left-handedness in a spiral depend on point of view. Inward or outward, upward or downward, from the object's point of view or the observer's—such decisions can only be arrived at by personal convention. Weston appears always to have chosen the spiral's direction in relation to the dynamic framing of his composition. According to my own convention, he seems to have preferred the left-handed spiral. To a right-handed person this is not a natural tendency, but we can easily correct the direction of the spiral by holding the image up to a mirror. When we do so we immediately notice some unsatisfactory effects upon the composition.

This phenomenon is clear in other Weston images as well. In *Pepper No. 30* (1930),[32] the highlight on the far-right curve is detached from its form in the reversed image and becomes mere line. The attention given to it on the left cannot match its weight and volume in its correct position on the right. Reversed in the mirror, *Nude* (1927)[32] lacks all its dynamism, and the higher right arm in Weston's image is reduced in the reversal to a limply extended left arm. All the leverage of the shorter arm pulling left in the correct image is lost. This is not the case in the correct position. Weston was extraordinarily sensitive to such effects within the frame. This was the form his sense of proportion took—perceptual orientation with regard to left- and right-handednesss, and its effect on dynamic movement within the frame.

In images like *Nude, 1934* (figure 28) and *Shell (13S), 1927,* (figure 29) whatever the direction of the basic spiral, there is a contrary twist on the calves and tapered end of the shell, respectively. This twist against the

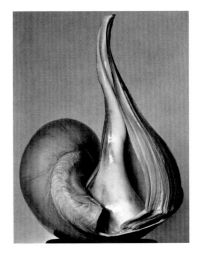

FIGURE 29:
Edward Weston,
Shell (13S), 1927.

general direction of the spiral Cook called *perversus*.[35] However, aesthetically speaking, if spherical or spiral forms are consistent with concentric vision, then *perversus* could be consonant with moral perversion. It is too easy to jump to a moral or psychological conclusion when in fact what is happening is that a "wrongness," "a not-quite-rightness," is unconsciously perceived in the images. Weston's work, responded to as "perverse" in some moral sense, is merely perplexing in the perceptual sense, and formally all the stronger for it. In terms of anthropomorphic delusion, Weston is often his own worst enemy. It is the left-hand curve on the tree in *Lake Tenaya* (1937),[34] that guarantees the image will be read as thighs, belly and ribcage as clearly as Steichen indicated that his image of sunflower stem should be, *Backbone and Ribs of a Sunflower* (1920).[35]

Bertha Wardell, whose face and red hair have never been seen by those of us who admire her as the subject of Weston's best figure studies, is a dancing torso that stands up to him in a way Charis Wilson's whole body never did. The reactionary neo-classicism of the influence of Thomas Couture in America makes the later nudes sentimental if not exploitative. By contrast, Wardell is a great sea-shell and a broken tree-stump ("Bertha is more definite than anyone I have met since Mexico, excepting Henrietta Shore.")[36] The dictionary tells us that the Italian word *torso* means a stalk or stump. Art history should make us aware that the bacchic thyrsus, a pinecone-tipped staff which has migrated to John the Baptist's hand as a cross, is analogically related to the tree or cross on which Christ died. It is surprising, however, to consider the possibility that Weston's tree stumps, like his nautilus shells, tap a rich iconographic tradition, as well as a biomorphic strain in modern art (plate 6).

The Wardell nudes, like the cypress roots and juniper trees, may be mutilated by cutting, but the torque on her ribs and backbone is an analogue of the twist on the tree-trunks that spells vigor. Such forms persuade us by their very force that they contain a significance beyond the merely physical. If the tree stump and the shell could represent death and resurrection simultaneously in traditional iconography, was it not possible to transform that iconography in biological terms? These forms would then celebrate the victory of nature over mathematics in Cook's terms, and, perhaps, of sexual innocence over experience in Weston's terms.

Charlot saw Weston's work as evidence of a contemplative life, "with this added security, that Nature being actually such as revealed in his well-focussed photographs, we come closer to the mechanical proof of its being, in essence, divine."[37] He made a drawing of Weston as an Oriental sage as early as 1924.[38] Charlot had begun his artistic life in Paris as a member of the Catholic Guilde de Notre Dame, whose spiritual leader was Maurice Denis, the Symbolist painter who in *Cézanne as Symbolist* (1907) gave Stieglitz the word *equivalent*: "Every work of art is a transposition, an impassioned equivalent, a caricature of some sensation experienced or, more usually, a psychological fact."[39] Or, as Charlot put it:

To describe physical biological phenomena, erosion, growth, etc., is to refer to similar happenings in our mental world. There is a mystery in the objective realm as loaded with meaning as are the voyages one makes into oneself. Weston has understood these things as few others have.[40]

Charlot as Catholic saw this mystery as divine; but Cook, probably like Weston, was not to be drawn into discussions of conscious design. "I am, in fact, not so much concerned with origins or reasons as with relations or resemblances."[41] The idea of the spiral appealed to Cook because it suggested that diversity in nature predominated over uniformity. True circles or closure proposed a model of total conformity, whereas the spiral asserted the idea of an ever-expanding diversion from the norm. For the same reason, although Cook sought mathematical descriptions of spiral forms, he denied that life and beauty in art were mathematically exact. He was a vitalist and a Darwinist who stressed difference from the typical.

The origin of species and the survival of the fittest were largely due to those differences from type, those minute adaptations to environment, which enabled one living creature to pass on its bodily developments to an improved descendant."[42]

The individual nautilus shell could no more be explained by mathematics than the human could be explained by genetics. Adaptation left room for individualism. Cook, the Olympic athlete, was oddly matched with Weston, the vegetarian. Of course, the vitalist ideology they shared through Steichen had political implications. They could never be collectivists, but behind them stood John Ruskin, an early spiralist who

became a collectivist, and whose concept of vital and typical beauty expressed both the possibility of unconscious design on the one hand, and conscious design by God on the other. Charlot's sense of the divine included both aspects. Weston emphasized vital beauty, but seems to have been aware of the other kind.

NOTES

1. Theodore A. Cook, *The Curves of Life* (London: Crown, 1914), 289.
2. Edward Steichen, *A Life in Photography* (London, 1963), n.p.
3. Steichen, n.p.
4. Anne K. Hammond, "Frederick Evans, 1853-1943: The Interior Vision," *Creative Camera* 243, London, March 1985, 12-26.
5. Peter C. Bunnell, ed., *Edward Weston on Photography* (Salt Lake City: Peregrine Smith Books, 1983), 24-25.
6. See *Macmillan Biographical Encyclopedia of Photographic Artists* (London & New York, 1983), 252. This suggests that Hagemeyer took up photography after he had met Steichen in New York, but I have been unable to corroborate this statement.
7. Jean Charlot, unpublished typescript, Charlot Collection, Thomas Hale Hamilton Library, University of Hawaii, Manoa. (Published here by kind permission of the Charlot Collection; special thanks to Peter Morse for drawing it to my attention.)
8. Amy Conger, *Edward Weston in Mexico: 1923-1926* (Albuquerque: University of New Mexico, 1983), plate 7.
9. Charlot, typescript cited above.
10. Jean Charlot, *An Artist on Art* (Honolulu: University of Hawaii Press, 1972), I: 13-14.
11. Julio C. Orozco, *An Autobiography* (Austin: University of Texas Press, 1962), 144-145. By 1943 Weston was using "Dynamic Symmetry" as a joke title (See *Edward Weston: Photographer* (Millerton, N.Y.: Aperture, 1965), 77.
12. Steichen, n.p.
13. Illustrated in Katherine Kelsey Foley, *Edward Weston's Gifts to His Sister* (Dayton: The Dayton Art Institute, 1978), 53.
14. Steichen, n.p.
15. Charlot, I: 23.
16. *The Charlot Collection of Edward Weston Photographs* (Honolulu, 1984), 32.
17. Charlot, I: 46-48.
18. Cook, 19.
19. Steichen, n.p.

20. Steichen, plate 65.

21. Steichen, plate 64.

22. Ben Maddow, *Edward Weston: His Life and Photographs* (Millerton, N.Y.: Aperture, 1979), 149.

23. Charlot, I: 96-97.

24. Bunnell, 61, 50.

25. Merle Armitage, *Henrietta Shore*, with an article by Edward Weston and an appraisal by R. Poland (New York: Wehye, 1933).

26. See D. Bry, *Alfred Stieglitz: Photographer* (Boston: The Museum of Fine Art, 1965), plate 34: Dancing Trees (1921).

27. Charlot, I: 196; Maddow (1979), 70.

28. *Stilleben in Europa* (Münster, 1979).

29. Illustrated in Foley, 34.

30. Steichen, plate 72; Maddow (1979), 145.

31. Maddow (1979), 297.

32. Charis Wilson, *Edward Weston: Nudes* (Millerton, N.Y.: Aperture, 1977), 53.

33. Cook, 207-209.

34. *Charlot Collection of Edward Weston Photographs*, cover.

35. Steichen, plate 78.

36. Maddow, 71.

37. Charlot, I: 176.

38. *Charlot Collection of Edward Weston Photographs*, frontispiece.

39. Cited in H. Osborne, ed., *Oxford Companion to Art* (Oxford, 1984), 1117.

40. Charlot, I: 174.

41. Cook, 4.

42. Cook, ix.

EDWARD WESTON'S LATE LANDSCAPES

"I have not attempted to make a geographical, historical or sociological record. My work this year as in the past has been directed toward photographing Life."
—Edward Weston, CAMERA CRAFT, February 1939[1]

BY ANDY GRUNDBERG

IT HAS BECOME A CONVENTION OF PHOTOGRAPHIC HISTORY to speak of Edward Weston's incredibly fertile and multifaceted career in terms of a number of distinct and separate sub-careers. To take but one example, biographer Ben Maddow follows Weston through such "periods" as pre-Mexican (1918-1923), Mexican (1923-1927), pre-Guggenheim (1927-1937), Guggenheim (1937-1939) and post-Guggenheim (1939-1948).[2] And there is widespread, if not unanimous agreement that, of all these periods, the work from the early 1930s (that is, "pre-Guggenheim") including Weston's close-up portrayals of vegetables and a series of equally dramatic nudes, is the strongest of his career.[3] On the other hand, much of Weston's work from his last ten years as an active photographer—from 1939 to 1948, when Parkinson's disease finally made it impossible for him to photograph—carries the taint of failure in the eyes of many of his avid fans. This is especially true of his "satiric" pictures, taken during the war years, and of his sentimental records of his housecats, which represent something of an embarrassment to virtually all of the photographer's otherwise staunch supporters.

There is evidence, however, that Weston's mature, Modernist career is not comprised of a series of progressive periods based on biographical events, but that it is divided quite decisively and dramatically into two parts. The first, dating to 1937, is concerned primarily with formal abstraction and is expressive of Weston's libidinal preoccupations; the second, from 1937 on, is marked by an increasingly open style involved with complex spatial organization and pictorial depth, while conveying intimations of ruin, decay and death.[4] Weston's assertion in 1939 that his intention during the two years of his Guggenheim grant was "photographing Life" is, in retrospect, ironic. For beginning with the Guggenheim project—and perhaps without the artist reading it—the subject of Weston's photography became Death.

PLATE 7, OPPOSITE:
Edward Weston,
Woodland Plantation, Louisiana, 1941.

This late work, which consists in large measure of landscapes, also contains evidence of a political consciousness that was absent in Weston's earlier photography, which is made up primarily of portraits, nudes and close-ups of natural forms. In the last ten years of his working life, Weston perceived the American landscape not as something grand, primordial and innocent, but as inhabited, acculturated and, in many places, despoiled. Not only do many of his pictures from this era recall Walker Evans' photography of the thirties, but they also point directly to the landscape photography of the late 1970s—that is, to the socially conscious but stylistically restrained "New Topographic" mode of photographers such as Robert Adams, Lewis Baltz, Joe Deal, Frank Gohlke and Stephen Shore. One need only compare Weston's image of a coffee cup sign in the Mojave Desert (titled *Siberia* in *California and the West*,[5] the published collection of his Guggenheim work) with a picture like Robert Adams' *On Top of Flagstaff Mountain, Boulder County, Colorado*, reproduced in *From the Missouri West*,[6] which shows a trash can in the foreground of an otherwise scenic vista, to sense how much Weston's vision had veered from its earlier High Modernist trajectory.

Beaumont Newhall, in the 1982 edition of his *The History of Photography*, takes note of the change, saying that with the 1937 Guggenheim grant Weston's "style expanded, the variety of subject matter increased and a rich human quality pervaded his later work." And John Szarkowski, characteristically, articulates it most persuasively. Writing in *American Landscapes* (Museum of Modern Art, New York, 1981), he notes, "Until the mid-1930s [Weston] tended to avoid the horizon, or use it as a beautiful line, a graphic obligato at the top of the picture, contenting himself with an order that could be managed in a taut, shallow space, almost in two dimensions. But by the late 1930s, when he was at the height of his powers, no space seemed too broad or deep for him." Clearly, Szarkowski's view of Weston's career does not follow received opinion.

It is perhaps even not too farfetched to suggest that Weston's late landscapes helped point photography away from photographic Modernism's preoccupation with reductive abstraction and toward a more capacious, complex, naturalistic and stylistically transparent style. It is clear from the pictures in *California and the West* and from those in the Limited Editions Club's volume of Walt Whitman's *Leaves of Grass*,[7] which Weston was assigned to illustrate in 1941, that the photographer's way of seeing became, in his last decade of work, less reductive, less

dramatic and less insistently graphic, while becoming more inclusive, accepting and—given its theme—resigned.

This is not to suggest that the photographer "discovered" the landscape as a subject in the late 1930s; he began taking views of distant land and sky forms on his arrival in Mexico in 1923.[8] He even allowed signs of human presence to penetrate his otherwise clinical compositions of the time. But as much as they prefigure aspects of the later work, the Mexican landscapes are different. Some, including views of the villages of Janitzio and Patzcuaro, seem composed according to Cubist models; others, like his 1923 image of the Piramide del Sol, are iconic if not monumental. In a photograph which the scholar Amy Conger has identified as Weston's first cloud-form picture,[9] a towering nimbus fills the vertical frame; the cloud's resemblance to male genitalia is so marked it hardly needs to be remarked on. (Weston's trip to Mexico was, one might note, his first assertion of his own artistic independence —and of his independence from his wife.)

By the time Weston set out in 1937 with a new Ford, $2,000 from the Guggenheim Foundation and a $50-per-month contract to supply scenic photographs for *Westways* magazine, he was a much more self-confident artist than the one who had sailed for Mexico in 1923. He had the security of a mature artistic style—one that had made him a commanding figure in photography circles nationwide—and he was an articulate, admired spokesman for the Purist aesthetic. He was 51, a mid-career photographer with grown sons; a young, intelligent and "liberated" lover (Charis Wilson, soon to be his wife) and the distinction of having just received the first Guggenheim ever awarded to a photographer.

But instead of pictures of phallic clouds and recumbent nudes that would celebrate his artistic empowerment and vitality, Weston proceeded to take landscapes of a distinctly elegiac tenor. Among the subjects recorded on the 1,500 negatives he made between 1937 and 1939[10] are a burnt-out automobile, a wrecked car, an abandoned soda works, a dead man, a crumbling building in a Nevada ghost town, long views of Death Valley, the skull of a steer, the charred remnants of a forest fire, gravestones and the twisted, bleached bark of juniper trees— a virtual catalogue of decay, dissolution and ruin.

Not all of the Guggenheim work fits this category, of course. There are enough photographs of "innocent" subjects—dunes, cloud studies, majestic views of mountaintops, valleys and the Pacific coastline—to

suggest that Weston was not exclusively preoccupied with death. However, this does not negate the fact that decay, dissolution and ruin were new additions to Weston's artistic repertory at the time, and that their existence signals a fundamental turn in the photographer's themes and, coincidentally, his style.

The stylistic differences are readily obvious if one compares, for example, his Oceano sand dune pictures of 1936 with his Death Valley dunes of 1938. The former are dramatic, abstractly seen and ambiguous in scale; they look, remarkably enough, like American Abstract Expressionist painting of fifteen years later. The latter are less radically cropped and more naturalistic, with undulating lines that sweep the eye off into deep space. A similar change can be seen by comparing his 4-by-5-inch nudes of 1934 with a nude image of Charis taken in New Mexico in 1937. The 1934 pictures are studio constructs, studies in form and flesh tones taken against a dark backdrop; the 1937 image is more like a landscape, with Charis lying on a blanket in front of an adobe wall, a shadowed oven, like a tunnel, beyond her raised knee. The combination of figure and background give the photograph an erotic resonance unequaled by the more decorous studio nudes.

The change in photographic style from a strictly organized, close-up and exclusionary formalism to a more relaxed and inclusive naturalism is inseparable from the expansion of Weston's range of subject matter during the Guggenheim project. His ability to encompass entire towns within his frame—places like Jerome, Arizona, and Albion, California —harks back to the nineteenth-century promotional photography of Carleton E. Watkins. Weston's interest in the land also extended to hayfields, vineyards and even the harbor of San Francisco. These pictures, following by less than ten years his close-ups of shells and vegetables, represent a decisive step away from the increasingly circumscribed High Modernist practice of Alfred Stieglitz—a break that seems to have gone unrecorded in the criticism of the time, and is barely spoken of today.

In applying for the Guggenheim Fellowship, Weston apparently did not anticipate the dramatic change coming over his work. He couched his plan to travel throughout the West (especially in California) in terms of a continuation of his artistic concerns. His initial application read, "I wish to continue an epic series of photographs of the West, begun about 1929; this will include a range from satires on advertising to ranch life, from beach kelp to mountains. The publication of the above seems

assured."[11] Later, he elaborated on this laconic proposal in a letter to Henry Allen Moe of the Guggenheim Foundation, "In a single day's work, within the radius of a mile, I might discover and record the skeleton of a bird, a blossoming fruit tree, a cloud, a smokestack; each of these being not only a part of the whole, but each—in itself—becoming a symbol for the whole, of life."[12]

What exactly constituted "satires on advertising" in his work at the time is unclear (unless we dare to presume he meant *Pepper No.30* and his other vegetable pictures to function in this way); however, in pictures like *Hot Coffee*, taken during his Guggenheim travels, his intention becomes apparent. Also of interest, in retrospect, is his elaboration of potential subject matter in the letter to Moe; as it turned out, bird skeletons, fruit trees, clouds and smokestacks do not make up a significant part of his actual accomplishment. Instead of using the detail to make "a symbol for the whole," Weston in actual practice attempted to fit the whole within the frame.

This tendency continued in his next major project, a series of landscapes and portraits taken to illustrate Walt Whitman's great nineteenth-century American epic poem *Leaves of Grass*. Weston was commissioned by the Limited Editions Club in 1941 and spent ten months traveling to twenty-four states, logging some 20,000 miles.[13] In many cases the photographs Weston made for the *Leaves of Grass* project are recapitulations of the advances made during his Guggenheim travels, and some might be judged as merely obligatory exposures. (Weston was, after all, on assignment, a condition that never fully agreed with him.) But in two respects they are novel: for one, many of them are, in the words of Maddow, "frankly funereal;"[14] for another, they embrace urban civilization and industry to a degree unprecedented in Weston's career.

It seems likely that the photographic message of the forty-nine pictures chosen for reproduction by the Limited Editions Club is purposefully less depressing than a representative selection of the photographs Weston made on his cross-country tour would have been. With one exception (figure 30), graveyards and gravestones are not among the subjects selected for the book, yet Weston seems to have stopped to record them wherever he went. Nor is much weight given to his pictures of crumbling southern plantations (plate 7), so Walker Evans-like in both form and feeling, or of the log-cabin culture of rural poverty Weston kept seeing in the South (figure 31). Instead, in the

published work there are an abundance of images of steel bridges, rail yards, skyscrapers and other indications of "progress" in the spirit of Whitman. These are, on the one hand, antidotes to the images of ruin and decay that managed to survive the editing process (most of which, tellingly, were taken in the South) and, on the other, topographic "inhabited landscapes" that survey the changing face of America with a nearly neutral, even spectral, gaze.

The difference between Weston's early and late styles is nowhere more apparent than in the gulf between the work he did on Point Lobos in the years 1929 to 1934 and his Point Lobos pictures of 1939, 1940 and 1944 to 1948, the last having been made when the progressively crippling effects of his Parkinson's disease had become unmistakable. In the earlier work, eroded rocks on the beach are isolated by the camera so that their scale and context are eradicated, thereby emphasizing their poetic, metonymic qualities. (Many, it goes without saying, resemble torsos.) The fluid lines and liquid surfaces of kelp are emphasized in vivid close-ups, and the roots of cypress trees are shown to have all the potential energy and pent-up power of ocean waves. In the photographs from 1939 on, however, the Point Lobos peninsula is a veritable theater of death. Dead pelicans and dead kelp float in translucent pools; the cypress

FIGURE 31:
Edward Weston,
"Land of those sweet-air'd interminable plateaus! Land of the herd, the garden, the healthy house of adobe!"

trees are shown whole, their bare limbs white and wizened; rocky cliffs appear as jumbled as if a landslide had just struck.

In *California and the West*, Charis Wilson, Weston's wife from 1939 to 1946, took note of Weston's initial resistance to returning to Point Lobos as a subject near the end of his Guggenheim years: "Edward began by saying that he was all through with it. . . . Hadn't he photographed every twisted cypress on the cliffs and every eroded rock on the beaches? True enough, but that had been a period of close-ups: details of rocks, fragments of trees." More recently she has remarked that "Edward was a confirmed reductionist, apt to prune and snip and condense ideas until nothing remained but a bit of branchless stalk. . . ."[15] Her choice of words seems to indicate that she recognized the photographer's penchant for elimination and reduction as something less than completely auspicious—a feeling not expressed by any of Weston's other intimates, who included Beaumont and Nancy Newhall, Willard Van Dyke and Ansel Adams. We might surmise, given her attitude and the correspondence of Weston's change in style with her entry into his life (they first met in late 1933, and became lovers in the spring of 1934), that Charis was, in fact, part of the process of weaning him from his "reductionist" ways.

Certainly their relationship, which followed on the heels of a score of love affairs and years of compulsive womanizing on Weston's part, served as a token of the photographer's growing self-assurance in the world. It is not unreasonable to assume that, as he became less anxious and more expansive in his personal life, he felt less need to exclude so much of the world. The fact that his last ten years as an active artist were devoted primarily to landscapes, and that he became involved with first the West and then the United States as a subject, signals a new, extroverted Weston. It is this Weston who then turns from the realm of the erotic to consider the specter of death in the living, visible world.

One can, of course, cite other influences to account for the more open, capacious style of Weston's late landscapes. There was the example of Ansel Adams, with whom Weston photographed in Yosemite during the Guggenheim years. There was the example of Eugene Atget, whose ethereal and haunted pictures of Paris and its environs came to the American photographer's attention in 1930. And it seems likely that Weston also knew Walker Evans' pictures of the South, taken for the Farm Security Administration in the 1930s. Unlike Adams, both Atget and Evans dwelt on evidence of cultural dissolution. But whatever the reasons—and surely they were plural—Weston's shift from High Modernist to Late Modernist style constitutes a crowning accomplishment in a career remarkable for its sheer number of achievements. That this shift occurred just at the historical moment when High Modernist style was beginning to ossify into mannerism places Weston's late landscapes in the forefront of the major aesthetic watershed of mid-twentieth-century photography.

NOTES

1. Edward Weston, Peter C. Bunnell, ed., *Edward Weston: On Photography* (Salt Lake City: Peregrine Smith Books, 1983), 88.
2. See the contents page and textual organization generally of Ben Maddow, *Edward Weston: His Life and Photographs* (Millerton, N.Y.: Aperture, 1979). Maddow, the "official" Weston biographer after Nancy Newhall, does not account for the period from 1902, when Weston first took up the camera, to 1918.

3. For example, Peter C. Bunnell observes in his recent anthology of Weston's writings, *Edward Weston: On Photography*, that the years 1927 to 1934 constitute "the most significant of [Weston's] periods," xviii.

4. See Andy Grundberg, "Edward Weston Rethought," *Art in America*, July-August 1975, for a discussion that broaches the psychoanalytic dimensions of Weston's oeuvre and couches its division in the Freudian terms of eros and thanatos.

5. Edward Weston, *California and the West* (Duell, Sloan and Pierce: New York, 1940), reprinted (Millerton, N. Y.: Aperture, 1978).

6. Robert Adams, *From the Missouri West* (Millerton, N. Y.: Aperture, 1980).

7. Walt Whitman, *The Leaves of Grass* (New York: The Limited Editions Club, 1942), reprinted as *Edward Weston, Leaves of Grass by Walt Whitman* (New York: Paddington Press, 1976).

8. Amy Conger, *Edward Weston in Mexico: 1923-1926* (Albuquerque: University of New Mexico Press, 1983), 7.

9. *Ibid.*

10. Edward Weston, "Of the West/A Guggenheim Portrait," *U. S. Camera Annual*, 1940, 37, reprinted in Bunnell, 114.

11. Bunnell, 78.

12. Bunnell, 79.

13. Maddow, 268-269; Richard Ehrlich's introduction to *Edward Weston: Leaves of Grass*, iii.

14. Ehrlich, 268.

15. Letter from Charis Wilson to Peter Bunnell, April 25, 1981, quoted in Bunnell, xx.

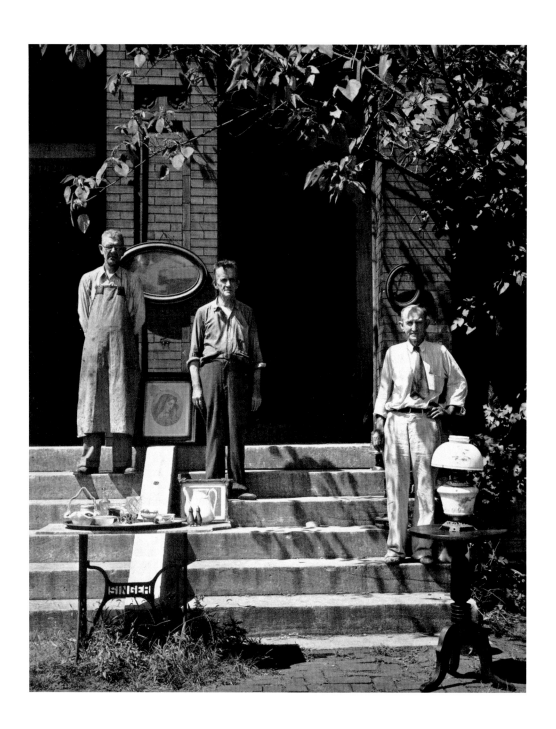

EDWARD
WESTON'S
AMERICA:

The
Leaves of Grass
Project

BY ALAN TRACHTENBERG

AMONG THE LESSER KNOWN WORKS OF AMERICAN PHOTOG-raphy is a 1942 Limited Editions Club publication of *Leaves of Grass* with reproductions of forty-nine photographs by Edward Weston.[1] Many of the images are separately quite well known, though they are more likely identified by date and location with the cross-country tour Weston and his wife/collaborator Charis Wilson undertook for the Limited Editions commission than with the resulting publication itself.[2] But the group of forty-nine published photographs has hardly been noticed and com-mented upon as such, as a distinct whole determined by a relation to Walt Whitman's poem.

Inaccessibility of the text is one large reason for this neglect, but another, more provocative explanation may lie in the uneasy character of the project itself. It was, in the first place, a rather odd assignment for Weston; indeed his insistence that "there will be no attempt to 'illustrate'," "no titles, no captions,"[3] implies reservations: the risk of subordinating pictures to text, to any function external to their own self-determined communication. Moreover, the publication itself proved something of a botch. Although he signed each of the 1,500 numbered, two-volumed boxed sets on the colophon at the end of the second volume, Weston was distressed with the final look of the project, especially with the appearance, against his wishes, of captions in the form of some lines of Whitman's verse under each of the otherwise quite beautifully printed reproductions of the photographs.[4] The final product seemed to warrant Weston's fear of loss of control; the photographer's role in the production of the book seemed to extend no further than the submission of seventy-two pictures from which, according to the original arrangement, fifty-four were to be chosen. In the end, only forty-nine appeared.

Can we speak, then, of a true collaboration between photographer and poet, of the book's reflecting Weston's engagement with Whitman? With forty-nine pictures (including two frontispieces) scattered among some two hundred and sixty pages of text, the images seem spliced at random into the two volumes without much regard for mutual resonances. To be sure, captions drawn from Whitman's verse do serve as pointers of a kind, but the pictures remain unintegrated, tokens chiefly of another presence, one alongside—in the shadow of—the commanding figure and voice of the poet.

We can imagine what might have been: a book designed to *feature* the

PLATE 8, OPPOSITE:
Edward Weston,
*"And such as it is to be of these more or less
I am, And of these one and all I weave the
song of myself"*

encounter of photographer and poet, of image and text. Imagine *Leaves of Grass* as Weston's shooting script. The compatabilities between the two original American artists seem ample indeed: the organicism they share, the sense of the wholeness of things, the order behind and yet palpable in the least conspicuous of natural things, in "mossy scabs of the worm fence, heap'd stones, elder, mullein and poke-weed." Weston's famous 1930 statement rings with accents of Whitman's *Leaves*: "Life is a coherent whole: rocks, clouds, trees, shells, torsos, smokestacks, peppers are interrelated, interdependent parts of the whole. Rhythms from one become symbols of all." The extraordinary sense of physicality in Weston's pictures, the *thereness* of his places, his lavish textures, the tactile sensations: we can well imagine Whitman, who was a friend of Mathew Brady and Alexander Gardner, and a lover of photographs, glowing at the sight of Weston's vegetables, roots, rocks and nudes. Moreover, Weston often described his intentions as an artist in virtual echoes of Whitman's romanticism and radical individualism:

I am not trying to express myself through photography, impose my *personality upon nature (any manifestation of life) but without prejudice nor falsification to become* identified *with nature, to know things in their very essence, so that what I record is not an interpretation*—my *idea of what nature should be*—*but a* revelation *or a piercing of the smoke-screen artificially cast over life by irrelevant, humanly limited exigencies, into an absolute, impersonal recognition.*[5]

Equally as much as his eastern friends, Steiglitz, Strand and Sheeler, who shared with Whitman the inexhaustible theme of New York, of Manhattan, the Californian Weston might have counted himself among the many sons and daughters of Walt among the many early twentieth-century American artists who found in Whitman a precursor and a sanction.

It is not surprising, then, that Weston took the offer from the Limited Editions Club as a serious challenge, though one not to be accepted without circumspection. "To me the undertaking of such a project could not be a casual thing," he wrote to George Macy, director of the Club, in February 1941. Macy had suggested that because California alone was "such a melting pot of American types," a few months there would probably garner Weston all the pictures he would need. "I couldn't see it as merely the making of a few dozen negatives that

might be *apropos*," Weston continued in his reply. "Rather, it would mean the task of rendering visual the underlying themes, the objective realities, that make up Whitman's vision of America."[6] Only a cross-country tour, he wrote two weeks later, "would give me a chance to see and record the diversified multitudes that Whitman sings and catalogues."[7]

Rendering visual the underlying themes, the objective realities, that make up Whitman's vision of America. Weston's understanding of the project at this stage suggests that he might indeed use *Leaves of Grass* as a kind of script, at least as a guide to themes and "objective realities" capable of visualization. It suggests a willingness, moreover, to accept "Whitman's vision of America" as his own theme, to subordinate his own compulsions toward an original vision to the poet's. Two months later, however, in a well-known letter to the Newhalls, Weston insinuated another, more familiar note.

I have thought over the subject pro and con, questioned 'am I the one to do this?' This I should tell you; there will be no attempt to 'illustrate,' no symbolism except perhaps in a very broad sense, no effort to recapture Whitman's day. The reproductions, only 54, will have no titles, no captions. This leaves me great freedom—I can use anything from an airplane to a longshoreman. I do believe, with Guggenheim experience, I can and will do the best work of my life. Of course I will never please everyone with my *America—wouldn't try to.*[8]

In moving from Whitman's vision of "America" to "*my* America," Weston now seems to take the project full-heartedly and openly as his own. Indeed, the effortlessness of his appropriation of the project for his own purposes suggests a late awareness that his work, particularly the California pictures of 1937-1939, already embodied an "America" of its own.

We can only speculate. Doggedly a Californian, at home in its terrain and in its light, did Weston come to see the Whitman project as an opportunity to expand his range, to lay claim to an *American* identity, to join Stieglitz and Strand (and perhaps Walker Evans, whose 1938 Museum of Modern Art show and its catalogue, *American Photographs*, he must have known) in their less regional, more cosmopolitan conception of an American subject-matter? Certainly the Whitman assignment provided at the least an occasion for travel and work in regions hitherto unexplored: the city and country sections of the South,

New England, Pennsylvania and New York. Not that *Leaves of Grass* determined the itinerary; Weston's purpose was unmistakably to see with his own eyes, to look and see if indeed there was an "America" to be seen in his distinct way of seeing.

Freeing himself from any literal obligation to or dependency upon Whitman's text allowed the photographer to confront those more difficult relations between his work and the poet's vision of America, more difficult because they are indirect, allusive, less overt. Whitman's vision, however, was less of a material place than of an idea, an energy, a potentiality manifest in place. Can we speak of anything comparable in Weston's case—a vision founded upon an *idea* of nation, an idea immanent in the particulars of place?

Any serious effort to reconstruct Weston's vision of America must include, of course, a much larger body of pictures than those several hundred images produced during the 1941 cross-country trek. And even if we wish to gauge the effect upon Weston's "America" of the 1941 tour, the commission and the exercise of seeing in some measure through Whitman's eyes, then we should examine not only the forty-nine images reproduced in the published text, but the entire body of work, the unedited, as well as the edited part.

As there is little to go on in the way of written record about his reasoned views of such matters as Whitman's poetry and America, we can only surmise. Still, we might ask of the published images alone what they show of Weston's "*my* America." Of course it will prove a fine task of discrimination to separate the images from their appearance in the Whitman poem, and in the end, perhaps, we should not even try to quarantine the pictures from Whitman's inevitable (and over-determining) mediation. But provisionally, at least, we might observe that if only by subject matter—admittedly a weak measure—the *Leaves of Grass* pictures represent a widening of horizons, a more inclusive field for representation than we see in Weston's earlier work. We gain this impression from the larger number of city views and industrial forms, the greater variety of rural scenes and objects, and especially of quotidian portraiture. In this regard, the pictures reflect their sources in Weston's self-conscious effort simply to see more of the country than hitherto; a desire focussed by the commission, but also by Whitman's own inclusiveness of geographical and cultural regions.

There are certain features that seem to set these pictures apart from

Weston's earlier work, not dramatically, perhaps not decisively, but nonetheless distinctly. Taking his earlier California work as base, we can say that differences appear in a toned-down scale of things, a diminished vibrancy of light, a greater perspectival distance. Certainly the book offers fewer unforgettable images, fewer pictures which persuade us that we have never before seen such things, than we find in Weston's more familiar oeuvre. As Richard Ehrlich aptly puts it, most of the *Leaves of Grass* photographs "do not look like 'Westons'."[9] Compare, for example, the intense scrutiny of natural and human forms in the earlier work, the relentless close-ups, the radical foregroundings and fiercely arbitrary crops. The mark of a Weston seemed just this: photographic signs of a will-to-power over the visible world. Weston's camera typically seems a constructivist's instrument; visibility flows from it, rather than merely reflecting itself in its lens. Thus Weston's properly celebrated earlier pictures are de-familiarizing experiences, as modernist in their visual idiom of surprise as Gertrude Stein's "continuous present," her experiments to create a "space of time" in sentences and paragraphs.

By contrast, the *Leaves of Grass* pictures are less coercive, less severely composed, more accepting of conventional photographic norms for the viewing of city skylines or middle-distance landscapes. Less daring, they seem for that reason less *personal*, images less of new, urgent discoveries than of a world, a land and landscape, comfortable and satisfactory and *already* in place; not dependent for visibility on Weston's act of seeing. The diminishment we sense here surely derives to some degree from the conditions of the making of the pictures, the necessarily brief encounters, the hit-and-run aspect of the cross-country tour. The pictures convey these conditions in their lack of intimacy and of ease, notable especially in the portraits. Weston's America, as represented in the *Leaves of Grass* pictures, seems a land passed through rather than known and savored in all its particulars, the way California is known, savored and represented very much as *his* place in *California and the West*.[10]

Weston may well have sacrificed something for the sake of collaboration with a text of virtually sacral power. But still, he clearly intended no literal referentiality between picture and text, no illustrative connection, no "symbolism." Indeed, like Stieglitz and other early modernist photographers, Weston had long argued for the primacy of "ex-

pression" over subject-matter or content—for the "way of seeing" over the thing seen. "It is not certain subject matter that makes one contemporary," he wrote in 1934, "it is how you see *any* subject matter."[11] The pervasive use of the term "documentary" in the 1930s determined Weston to clarify his own intentions—always resolutely aesthetic and transcendental rather than social and political—in regard to contemporaneity. In 1939 he wrote about the California Guggenheim project:

Actually it was not at all documentary in the present popular sense of the word. I have not attempted to make a geographical, historical or sociological record. My work this year as in the past has been directed toward photographing Life. I have not been concerned with making records, cataloging subject matter. Rather, I have tried to sublimate my subject matter, to reveal its significance and to reveal Life through it.[12]

Substitute "America" for "Life," and the credo serves the Whitman project as well.

The notion of a subjectless photograph must have caused difficulties, however. The case itself, of the collaboration, placed a limit and a constraint on the photographer. Thus the forty-nine

FIGURE 33:
Edward Weston,
*"You road I enter upon and look around, I
believe you are not all that is here, I believe
that much unseen is also here"*

published images have distinct subjects, and categorical subjects relevant to the poem: rural landscapes, cities, industrial views, portraits of unnamed common folk. More so than in any other body of his work, the social makes itself felt here as of equal or greater power, in the shaping of things, to the natural. The contours of the land in figure 32 mark not only the presence of mankind but are also a shaping activity: roads, houses, plowed fields, stands of woods set against the ravages of wind and weather. In figure 33 a dirt road inscribes a social presence in a desert terrain—by itself perhaps an inconspicuous element in a landscape, but perceived as a figure or form continuous with railroad tracks and bridges (figure 34), with signal switches and telegraph wires and highways which flow through the American landscape as depicted here. It becomes an item in what we recognize as a subtle but incisive portrait of "commerce" or "communication," or simply a system of tangible connections among distant and remote places. By subject matter alone the pictures convey a palpable material order, the physical signs of a society.

But what sort of society, with what tensions, conflicts, crises, remains only dimly visible. The view seems static and stable, a world of equilibrious relations between city and country and wilderness.

FIGURE 34:
Edward Weston,
*"I see the tracks of the railroads of the earth,
I see the electric telegraphs of the earth"*

The signs of change are only the most general: a power pylon or railroad signal against a barren, unsettled landscape as in figure 35. The sense of a settled stillness may not be a wholly inaccurate view of America in 1941. But it is a curious view of a society in the cusp between Depression and World War, one perhaps more a function of Weston's passing-through relation to many of the places he photographed than of a deliberative response. Rather than a reasoned interpretation, it is the photographer's *dis*engagement from contemporary life we feel, a disengagement registered not only as an absence of signs of contemporaneity (in any case never a feature of Weston's "California," which is more a land of dunes and kelp than of people at work or places inscribed with social uses), but also as a compositional mode of detachment peculiar to these pictures.

Of course such a formula simplifies too much, but as a rule, it seems true that closeness typified Weston's best work from Mexico in the 1920s through the California project of 1937-1939. The vegetables and studio nudes may be the strongest examples, but we must also include those deceiving vistas of dunes and sloping hills and rocks by which, like the illusions of a Zen garden, the near is made to seem distant, at once far out and near in, at once an unobtainable vista and an intimate

FIGURE 35:
Edward Weston,
*"The far darting beams of the spirit, the
unloos'd dreams, You too with joy I sing"*

possession. In the Limited Editions pictures we are more aware of space as a given, as the medium of a distance we are not invited to collapse and overcome, but to respect and abide by. Space is an element of difference, of division among objects and people (plate 8). The power of spatiality to keep the world at a certain discrete distance is established in the very first picture in *Leaves of Grass* (figure 36), the hardy old banjo player in his Sunday suit, sans coat, seated on a step of what we can tell is a spacious porch of an old American house, a carpenter's version of Greek Revival. Palm fronds and two framing square columns contribute to the proscenium effect of the front steps on which the old man sits. And the camera places us at sufficient distance to allow that stage-effect, that space for performance which also establishes the viewer's role as audience.

In this case it is the distance of decorum, of respect, of vital engagement not with the old singer as such but with his performance. But we are also made aware of distances that isolate, that represent solitude and fragility. In the depths of certain pictures, in their receding distances, one senses not the timeless realm of the earlier pictures—time stopped in the close-ups, or frozen into reified traces of time's effect—but space *as* time, as duration beyond the capture of a camera. "An

FIGURE 36:
Edward Weston,
*"I hear America singing, the varied carols I
hear, Singing with open mouths their strong
melodious songs"*

essentially American thing," wrote Gertrude Stein, "this sense of a space of time and what is to be done with this space of time."[13]

Weston's pictures reveal a preoccupation, perhaps below the threshold of deliberate intent, of the burden of "space as time." It is not an exuberant, expansive America disclosed to Weston's camera here; even bridges and railroad tracks and tall buildings and towers seem oddly depleted of energy, depicted as *already finished* objects, inert things rather than continuing processes, or things of active, satisfying use. Weston's America in these pictures is an essentially unpeopled landscape, and the handful of portraits—eight of the forty-nine photographs—show little activity or overt energy; they suggest an inwardness, a withdrawal. Except for three strong head-and-bust close-ups, most are viewed from a long enough distance to prevent a vivid apprehension of the person— in the case of figure 37, the loss of feature behind the barrier of wagon wall underscores the distancing and separating effect of Weston's spaces in these pictures.

Do these pictorial features constitute, then, a coherent idea of America, an interpretative "my America" correlative to Whitman's? Unfortunately, circumstances intervened to cloud the issue: the fore-shortening of the 1941 trip by the outbreak of World War; Weston's

FIGURE 37:
Edward Weston,
*"The commonplace I sing; Your farm—your
work, trade, occupation"*

apparent dissatisfaction with the final version of the two-volume set. There seems to have been serious difference of views regarding the role of the photographs within the text. The November 1942 newsletter of the Limited Editions Club spoke of Weston's assignment as the making of "photographs of American faces and American places which, when printed in an edition of *Leaves of Grass*, would form for the reader a clear, real reproduction of the America which Walt Whitman celebrated in his poems."[14] It seems that the publisher, George Macy, had indeed expected a more literal tie between picture and poem, and it may have been to meet his anxiety that Charis Wilson selected lines from *Leaves of Grass* to accompany each of the seventy-two photographs Weston delivered in March 1942. The purpose of the accompanying lines seems to have been merely to indicate the pertinence of image to text, to indicate, that is, the redundancy of captions. Contrary to Weston's understanding and wishes, in the final publication each image appeared over a quotation from the poems (mostly the very lines selected by Charis Wilson), and usually on a page near the quoted line.

The effect (as the reproduced examples demonstrate) are not unfelicitous. In fact, with the 1976 Paddington Press reprint in hand, in which the captions have been removed (and in minor ways the order of

pictures altered), we can indeed see that the captioned images are essential to the resonance of picture and text. The quoted lines draw the image directly toward the text, into its discourse, without reducing the image to an illustrative role. Without the anchor of captions the photographs float within the text, baffling interpretation, in danger of appearing as merely decorative accent marks. The images are too distant from each other in the text itself to offer the reader a single coherent experience as a totality in their own right. Lacking the formal consistency of a separate portfolio, and the governing unity of a single idea of contemporary America, they fail to account for their presence, except by some imposed chain of connection.

Like the history of the project itself, the case of the captions points up what is most interesting in this episode in Weston's career: the strange encounter between an already mature non-illustrative, non-documentist photographer, a "purist," with one of the formative texts of self-conscious modern American culture. It is hard to imagine such a project succeeding. Viewed as a record of one of the most interesting struggles with photography of Weston's life—how to avoid the documentary mode while "rendering visible" Whitman's "vision of America" seems to have been his major challenge—the *Leaves of Grass* pictures deserve even closer scrutiny, as well as decent publication in their own right.

NOTES

1. Walt Whitman, *Leaves of Grass* (New York: The Limited Editions Club, 1942), reprinted as *Edward Weston, Leaves of Grass by Walt Whitman* (New York: Paddington Press Ltd., 1976).
2. The trip covered some 25,000 miles in ten months in 1941-1942, from Carmel, California, through the South, the Middle Atlantic states and parts of New England and the Middle West.
3. Nancy Newhall, ed., *Edward Weston, The Flame of Recognition* (Millerton, N. Y.: Aperture, 1971), 70.
4. For details, derived from an interview with Charis Wilson, see the excellent essay by E. John Bullard, "Edward Weston in Louisiana," in Clarence John Laughlin and E. John Bullard, *Edward Weston and Clarence John Laughlin: An Introduction to the Third World of Photography* (New Orleans: New Orleans Museum of Art, 1982), 15.

5. Peter C. Bunnell, ed., *Edward Weston on Photography* (Salt Lake City: Peregrine Smith Books, 1983), 67.

6. Bullard, 11.

7. *Ibid.*

8. Newhall, 70. "Guggenheim" refers to Weston's two fellowship years, 1937-1939, during which he photographed in California.

9. Richard Ehrlich, introduction, *Edward Weston Leaves of Grass by Walt Whitman* (New York: Paddington Press Ltd., 1976), vii.

10. It should be said, Charis Wilson's place as well. CF. Charis Wilson and Edward Weston, *California and the West* (Millerton, N. Y.: Aperture, 1978).

11. Nancy Newhall, ed., *The Daybooks of Edward Weston*, Volume II: California (Millerton, N. Y.: Aperture, 1966), 241.

12. Bunnell, 88.

13. Gertrude Stein, *Lectures in America* (Seattle: Le Beacon Presse, 1935), 160.

14. Ehrlich, v.

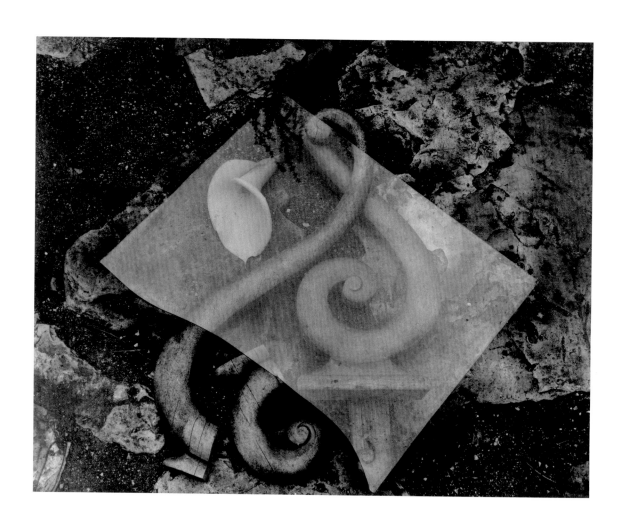

Watching Edward Weston at work during the 1930s and 1940s provided me with some vivid lessons in the art of photographic seeing. By the time we met, in 1934, Edward's eye had developed such selectivity and precision that he found memorable images in subjects as diverse as the polished tooth of a sperm whale, the radiating furrows of a lettuce ranch and the intricate design of an egg-slicer merging with its own shadow. I had never seen photographs like these before, and I marveled at their power to fix themselves in the mind of the beholder. How was this magic accomplished? I set out to find some answers, and in the course of the next twelve years I came to recognize a number of elements that contributed to the Weston vision.

This information was not to be gleaned from Edward's discussions with other photographers, since these tended to revolve around technical matters—how to get rid of blue stains, or what could cause desensitized spots in film. Nor was Edward a rewarding source when questioned directly. Except for wanting photographs to be sharp—and photographers to adhere to processes belonging to their medium—he had very little to say about technique, and even less about aesthetics. In his view, the picture-making faculty must develop out of an individual's whole response to life; thus, any "rules of composition" were meaningless formulas, and following them could only lead to the production of meaningless work. My understanding of the Weston eye had to be achieved by direct observation, and I became an inveterate observer, looking on the ground glass after every exposure.

In the beginning, there was a marked difference in the way we saw our surroundings. If we were both looking at the same desert scene, for example, I might try to imagine the geological forces that had shaped it, while Edward would note the relationships of forms and decide how the color values would register in black and white. My viewpoint tended to be literary; his was essentially pictorial. Once when we were driving in northern California along a road that wound between oak-dotted hills, we both laughed at the sight of a very large pink corset spread across the strands of a barbed wire fence. There were no buildings in the vicinity, in fact, none for many miles. We guessed that the garment had been flung from a passing car by someone who couldn't stand another moment of its torture.

I expressed keen enthusiasm for the picture possibilities, but Edward shook his head. When he finished making an exposure across the road,

THE WESTON EYE

by Charis Wilson

PLATE 9, OPPOSITE:
Edward Weston,
Lily and Rubbish, 1939.

he brought the camera over and focussed on the corset to show me what was wrong with it as a subject. First, it was not sufficiently shapely to hold its own as an image. Second, it was impossible to move the camera closer, and the angle from the road limited the background to out-of-focus grass. Third, parts of the corset and the barbed wire would be blurred because of the steady wind. "And don't forget," Edward added, as I stepped under the focusing cloth for a look, "It won't be pink!" The dramatic image in my mind—bleached hills and black oaks providing a classic background for a great pink crucified corset—gave way before the nondescript image on the ground glass. Clearly I needed to pay more attention to limitations, both geographic and photographic.

From years of working with an 8 x 10, Edward had acquired a mental view-finder that could separate a subject from its surroundings with great accuracy. He was never more pleased with his picture-making than when he could set up his camera in the "right" place, and have no need to move or adjust the tripod or change the focal length of the lens. He also took great pride in the speed and efficiency with which he focussed, took a light reading, decided on exposure, set the shutter, inserted a film-holder and pulled the slide. He was especially delighted if someone equipped with a small hand-camera and a bagful of gadgets proved to be slower than he was at setting up and making a picture.

This rapid action, in which the instrument seemed to be an extension of the operator's nervous system, was the product of years of simplification. His processes, methods and equipment had all been pared down to the barest essentials, and the activities of daily living had undergone similar treatment. Edward's guiding principles in both areas were simple and logical: Does it give me more time to photograph? More money for film? More storage space? Less time in the darkroom? He had a policy of not making duplicate negatives, which qualified on all four counts, and was further reinforced by his firm belief that a good photographer, working with a large camera, should be sufficiently sure of what he was doing to make the right exposure the first time.

He modified this viewpoint somewhat when faced with a subject in motion. If he thought movement might have spoiled the picture, he sometimes made two or more negatives. When he first saw the grass stalks on a cliff edge at Big Sur that he incorporated in the image *Grass against Sea, 1937*, they were rattling about in a steady breeze. "Early tomorrow morning," he announced confidently to the photographer

who was with us, "there'll be no wind. I can make a negative right at sunrise."

We spread our sleeping bags in an adjacent clearing, and Edward was up in the predawn stillness, morning coffee brewed, 8x10 set up and aimed, ready for the final adjustment of focus. Sure enough, when the first sun rays topped the Santa Lucia Mountains, the whole world seemed to be holding still—all except the grass on the cliff edge. I suppose it was the air column rising six hundred feet from sea level that set the feathery plumes trembling on their tall stems. Edward stood with his hand on the release, watching in exasperation as first one bearded grass stalk and then another bowed and shivered. Of the several exposures he made, only one was sharp enough to satisfy him.

Several months later, surf on the Northern California coast posed a different kind of problem. The sunlight was already dimming when Edward pointed his camera down a four hundred-foot bank at the shoreline. He tried to gauge the positions of the overlapping waves rolling in, the lacy white ebb running out, and the constantly changing foam patterns traced on the dark beach. There was too much action to keep track of, so for the sake of insurance he made a record four exposures. When they were developed he was reluctant to eliminate any of them, and in the end he kept two or three and showed them interchangeably as *Surf, Orick*.

Edward seldom had cause to regret his one-negative rule, and those failures he did have were usually due to malfunctioning equipment. A notable exception was the first of two pictures he made of a dead man we found while traveling on the Colorado Desert. All afternoon we had been driving along the sandy course of a dry river bed with the temperature over a hundred degrees, and no other car sighted for hours. At the Carrizo turn-off a note had been staked in the middle of the road saying, "Please help sick man at Carrizo Station." We found him lying under a tree on the creek bank, but by then he was beyond help.

The sun was ready to drop behind the Laguna Mountains before Edward decided that—in spite of encroaching shadows—he had to make a picture. The first one was a full view of the man's body. He was lying on his back, his feet toward the camera, one worn shoe off the bare foot. Set in a half-circle next to him were a tin cup of water, a half-bottle of milk and the bandana-wrapped bundle that held his few possessions. The image on the ground glass was haunting in its double message: the

desert had conquered the man with its scorching spaces and pitiless heat, but the man had succeeded in crossing that inhuman wasteland to die on a shady creek bank, with comforting objects around him.

As soon as Edward had made the exposure, he worked his way through the brush behind the tree and made a negative of the man's head. It was then we discovered that the holders and my exposure list did not match. Edward had failed to turn the little wire signal on one holder after exposing the film—but which film? There was only time to repeat a negative of the man's head before the light disappeared. Back in Los Angeles, when Edward developed his films, he found the full-length portrait of the dead man double-exposed with an image of some cow bones photographed earlier in the day. The picture that was a more complete biography of the man's last journey was lost.

During the years when Edward had been closely confined to a studio for fear of missing portrait sittings, he had devoted much of his creative energy to still-life photography. When he found a sufficiently challenging subject, he would make a series of variations, as he did with *juguetes* in Mexico, with shells in Glendale and with peppers in Carmel. In such a series, each new photograph might seem to him to be the ultimate rendering until it was surpassed by a succeeding version that revealed a new aspect, or provided a more penetrating view. Then one day he would realize he had said all he had to say about that particular subject, and he would be impatient to move on to new material. But it wasn't always easy to make a clean break.

In Carmel, friends who had learned to scan the grocer's bins with Weston-stimulated eyes persisted in bringing him radishes, peppers and squash long after his interest in these plant forms had reverted to the merely culinary. However, he did make two postscript vegetable pictures in 1936, when we were living in Santa Monica Canyon. The first was a cauliflower his son was cutting up for dinner; Cole noticed it had the classic *bonsai* form of a miniature tree, and it was such a lovely specimen that Edward couldn't resist. He curved a sheet of drawing paper behind it to enhance its delicate, high-key tones and made the photograph *Cauliflower*.

The other image, *Purple Cabbage*, was not, strictly speaking, a vegetable picture. Edward was charmed by the woven wicker garden seat at our rented house, but it was not a sufficiently interesting form to stand alone, and it made too busy a background for any average artifact.

I'm sure he thought of purple cabbage with the chair because the curls in the wicker reminded him of the halved cabbage he had photographed in Carmel six years before. We bought one at the market; Edward cut it into a half and two quarters and arranged the pieces on the wicker seat. By making the photograph in brilliant sunlight, he added the strong black shadows that balance the cabbage's white cores. That was the last photograph in which a vegetable made even a guest appearance.

Old shoes also kept appearing long after Edward felt he had exhausted their photographic potential. Shriveled and shrunken desert specimens were always the most poignant examples, and when such a pair came in the mail from his son Neil in 1942, Edward tried to find a suitable niche for them. Finally, like the small plants or animals that painters once used to break up vacant areas in their pictures, the shoes wound up in the lower right-hand corner of *Springtime, 1943*, an image of a nude behind a window screen. There, among other pictorial functions, they serve to break up the too insistent horizontal line of an outside pipe.

Edward's interest in subjects like old shoes is thought to be evidence of a morbid state of mind by some observers who imagine that his photographs of wrecked cars, dilapidated buildings and dead birds are signs of a preoccupation with his own mortality. The fact is, however, that Edward had always seen death and decay—along with birth and growth—as inseparable parts of the life process. Like many artists, he found objects and life-forms to be more interesting visually after they had been transformed and reshaped by the environment. He would probably not have looked twice at the main subject of *Wrecked Car, Crescent Beach*, if it had been a shiny new car instead of a unique model of utter dissolution. Nor would he have been likely to make dozens of photographs in Rhyolite, Nevada, if the buildings had been in prime condition instead of being the noble ruins that caused him to dub the place "America's Athens."

Edward's supposedly gloomy thoughts have also been held responsible for the many photographs he made in the old New Orleans cemeteries, yet it was there that he re-encountered that exuberant mingling of life and death which he had first witnessed twenty years earlier in Mexico, and which he believed to be profoundly natural and healthy. Undaunted by the intensely humid tropical heat, he donned a pith helmet to protect his bald spot, hung a bandana from it to shade his

neck and hauled his camera up and down the overgrown aisles of those "Cities of the Dead," where grasses, shrubs and even small trees came bursting through every crack in the masonry.

The view that Edward's photographs are often funereal has doubtless been nourished by the poor quality of many recent reproductions. An over-inked printing of his photograph of a ferryboat crossing San Francisco Bay in broad daylight, for example, looks like Charon's vessel crossing the Styx at midnight. Since Edward's original prints are in scarce supply these days, very little corrective information is fed into a system where comments on gloominess encourage somber reproductions that give rise to further comments on gloominess. This is especially unfortunate because Edward's photographs are so dependent on light. "Light is the photographer's subject," he was fond of saying, and his prints were made on glossy-surfaced paper to achieve a light-giving image. Heavy, dark reproductions can destroy the whole feeling of the original.

A case in point is his arrangement *Lily and Rubbish, 1939* (plate 9). After two years of travel on a Guggenheim Fellowship, mainly photographing landscapes or objects as he found them, Edward had worked up a keen appetite for making a still life. He had found a pair of wooden mirror brackets in an old barn, and he laid them out in various positions on our patio flagstones. To subdue their emphatic treble-clef form, he made a negative with a calla lily blossom and the head of a disintegrating plaster duck as counterpoint. I could tell he wasn't satisfied with that first attempt. He cast about for other material, and next time I looked he had eliminated the duck head and topped the arrangement with a piece of window glass that had been outdoors long enough to acquire a fine patina of dust. When he came out from under the focusing cloth his quick smile told me he was now on the right track, so I watched the final delicate adjustments and the addition of a genista sprig, the only bit of true black in the glass area.

One thing that gives the original picture a feeling of enchantment is the delicate light reflected and transmitted by the dusty "window." Because the glass itself is faintly luminous, the lily and the wooden brackets that lie beneath it seem to be bathed in a magical radiance. This effect is lost in heavy reproductions that darken the glass so there is no sharp contrast between what is seen through the glass and what lies around it. In addition to making a remarkable still life, Edward

had managed to spoof the venerable S-curve so dear to the hearts of old-fashioned art teachers by making a nest of intertwining "S"s and then cutting their curves with the sharp edges of the glass.

I do not mean that he consciously intended this while making the picture. He often said, "When I find myself stopping to think, I know I'm on the wrong track." When Edward photographed, he tuned out the thought processes—the judging, comparing, weighing and studying that usually mediate our relations with the world—and simply opened his eyes to all that lay before him. If his picture was there, he usually saw it instantly, almost as if it leapt out at him and demanded to be photographed. In the absence of such compulsion, he either pointed his camera elsewhere or put it away.

This kind of seeing—intuitive, intense and immediate—was the essence of Edward's creative gift. He may have honed his technical skills over the years, but ultimately, when we are confronted with his photographs, it is the Weston vision we respond to; it is the Weston eye that we are somehow seeing into as well as staring out of.

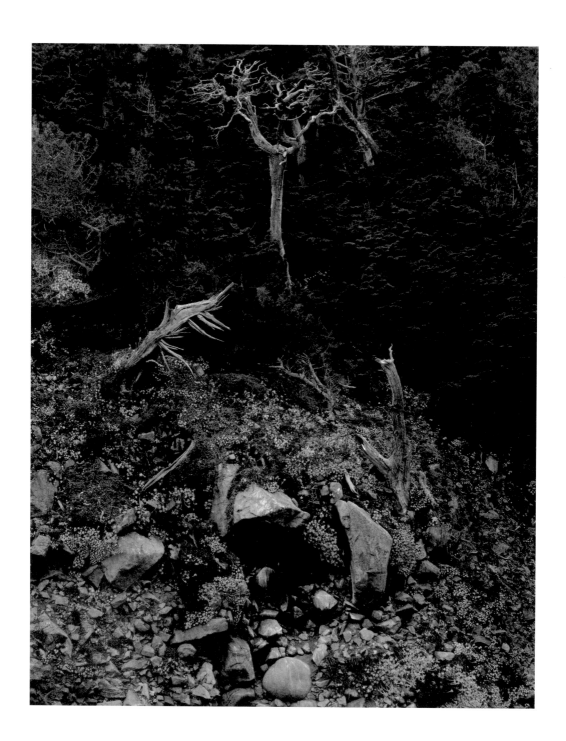

NO
MAGIC
WITHOUT
MAJESTY

BY PAUL VANDERBILT

IT WAS JUST ABOUT THAT TIME WHEN, QUITE BY ACCIDENT, I came across, on the bookshelf of a friend, a little book called *The Idea of the Holy*, by Rudolf Otto (1923). It was not that I was experiencing a rebirth, or was actually concerned with holiness; what attracted me among the subheadings, in this first fingering of the pages, was the exercise in specifying the exact nature of so impressive an abstraction. I am interested in semantics, in language and symbolism generally, but I am appalled at the strains put upon arbitrary and capricious phrasings in any effort to reach beyond the literal meanings that are assumed to underlie the whole system of words. I am also interested, at least in principle, in trying to specify—possibly in word reference, possibly by indirection—just what it is in a particular photograph, balanced somewhere between real and unreal, that puts it beyond words, into a posture of assurance that mere language, by nature vulnerable, can never attain.

But I forget quickly most of what I read, and mistrust most of what I retain as an author's tentative statement just waiting to be reversed by the next caseworker who addresses those points of fact. There remains the unknowable, the mysterious, the numinous fixed image. For I remember with burning intensity certain photographs—only a few—but those few I have looked at for hours on end.

Rudolf Otto actually lists the parts, "elements" he calls them, that make up not Holiness itself, nor the word *Holy*, but the Idea of the Holy, namely Awe, Overpowering Majesty, Urgency, Otherness, Fascination, Sublimity and, in a special sense, Eroticism. His little book is well-known among philosophers of religion, but I feel sure that the precision with which he discusses the ingredients of an idea must have led others to apply his eloquent line of thought in other fields, just as it has led me to see in his method a way toward photographic clarification.

I know precisely which two photographs of my own, made over ten years ago, started me in the habit of looking for magic in the field whenever I was working. Neither was perceived as magic when the negative was exposed; rather, this idea developed from looking at the not very remarkable prints, trying to wear them down, find their weakness, make them expendable. I did not exactly see the magic in the prints themselves, certainly not in anything about their relatively commonplace subjects, in both cases details of the landscape. The magic consisted of the simultaneous focus of factors very like those specifications for what we think of as holy, though at that time I had never heard

PLATE 10, OPPOSITE:
Edward Weston,
North Wall, Point Lobos, 1946.

of Rudolf Otto. In some lighted wood I came to, some placement of ancient stones, there were fearful threats, domination, excitement, pantomime, caricature and exaggeration, apparent rather than actual distortion, the sense that there is something more and larger, but hidden from view. I took to looking for magic as a presence, something that happened as I explored, much like a change in temperature. It was not subject in any sense, but it was material, a property of real, identifiable things, not as I saw them before me, but as though they were structured and disposed by a sight other than mine. All the natural "world" was accessible to me, at various levels of knowledge, but this magic was supernatural and beyond me, not by any defect in my own capacity, but by the organization of a hierarchy of circumstances, some frontiers of which I was not supposed to know.

It is essential for me, in a photograph of what seems to me to be abstraction, that the "subject matter" be "real," identifiable, even familiar, but that it appear as though that material "reality" had been removed, somehow filtered out, and that the picture was of what remained as residual character, as likely to be found in another subject, similarly abstracted, as in this one. Thus photographs of interest and quality, even identified portraits, turn out to have a content quite other than that limited by the initial assumption.

I was working professionally at the time with great quantities of factual photographs generally used for practical purposes, and I came to look, when I could, for underlying feelings that some might call "moods," but which I would prefer to call, in the most general sense, spiritual elements. These were almost never resemblances of form, very rarely symbols or metaphors, and never psychological guesswork. And it was much the same photographing in the field for a very special but related purpose.

Actually, during that period, I was photographing almost exclusively in the interest of enlivening older pictures from various sources in a historical collection of which I was curator. I wanted to put some of these rather routine pictures, generally of people and not in themselves outstanding, side-by-side with such photographs of suggestive mystery as would modify the stark literalness of the former and relate them by inference to the human universals that must underlie, if not dominate, any such fragmentary images drawn from life. I wanted a photograph of what I found in the field to use in a missionary sense, to elevate spiritually some other picture of earthier origins. But that project is

another, longer story.

It came about naturally that certain well-known photographs, of which I cut out reproductions to set up where I saw them all the time, became "key" pictures, or models for both phases of this operation. These few were all photographs that had, to some degree of perfection, a distillation of essence from the nominal material. I avoided any temptation to extract the same essence from that same material, but did indeed try to reach a more or less equivalent channel of abstraction, and to experience, if I could, a similar ecstasy. One of the two most lasting of these key models was Edward Weston's *North Wall* (plate 10), from his work at Point Lobos in 1946. I came to have, for that particular picture, consistent feelings usually reserved for living persons.

Weston is not actually my favorite photographer, but he has been, at least through that picture, one of the most influential. His work has provided me with incentives, with an almost map-like indication of directions and routes to explore; my "favorite photographers," usually working primarily with people as subjects, are masterful in ways I have no capacity to try to follow. The emotion on seeing "favorites" is likely to be immediate, but an influence may be felt only much later, after prolonged uncertainty and weighing, with some discarding and redirection.

I have neither the ability nor the inclination to analyze these "key" pictures; I let them run free and pay attention to whatever they engender. If, a little further on, this writing seems analytical, it is Rudolf Otto's examination of an idea that concerns me as method, and only by analogy is it an analysis of a Weston photograph. I have profited from private exercises in association—the more far-fetched and extravagant the better—attempts to search out abstract content in the most representational photographs, looking for pictures of something that is not there. Years ago, when it was first published, I took Eliot Porter's book on Glen Canyon, made color slides of about half the pictures and paired them associatively with conventional academic fields as I sensed them: this vista for the presumed characteristic thought-patterns of the Department of Modern History; this elaborate pool for the tortuous formulations of the Law School, and so forth. It was pretentious but harmless, and it remained private. Most people would directly weigh the *accuracy* of my association and would probably attack it, but I thought that accuracy was immaterial here and was happy with a figurative assumption, the mere possibility of such an analogy, however

false in its particulars. Following such exploratory trails, it was not long before I came to consider the *North Wall* as a religious picture.

There are, in basic Christian symbolism, the two trees: the Tree of Knowledge, in the Fall, and the Tree of Salvation, which is the Cross. If this photograph relates so quickly to supreme sacrifice, it is not because it might be thought to look like a crucifixion, but because the original concept of the symbolic representation of crucifixion, blending terror and worship, derives from such a schema, one fixed in the primitive consciousness by some visual experience of nature thousands of years before any idea of factual reporting. Is not the ability to think in analogies and to respond to metaphors one of the principal steps in an evolving intelligence? And is not the little word "like" of positively overwhelming importance in the history of human thought? Thinking in words is directed thinking, a relatively modern development compared to thinking in images, piling image on floating image, rearranging things in dreamlike but powerful fantasies.

It may be foolish to try to describe in words the metaphorical or purely associative content of an existing photograph, but it cannot be entirely futile to create another photograph that induces a line of undirected thinking and leads inevitably to the analogous level or quality of response, without any need to specify the identifying area. I would not call this self-expression, but a reaching beyond individual experience into universals before which the photographer himself is humble and dependent.

There are some remarkable examples among the plates in the Paul Strand volumes published by *Aperture*, pairings on facing pages that I am told were arranged by Strand himself. Here, extremely sensitive, quiet portraits are paired with details from that person's environment with the effect that each complex of natural detail is a metaphor for the state of mind of that individual, not necessarily at the moment of that portrait, but as a matter of texture, grain, flow and reserved energy, as characteristic as such an abstraction can be of a whole phase of his general experience. I recall particularly the sharp, shrunken, dry features in close-up of an old woman scarved in black, straight out of ancient legend, paired with the tortured bare branches of a dead and whitened tree, flashing like lightning, shrill and wild, violent as a torrent of obsessive wrongs. And I remember the strung-out seaweed, with the standing fisherman and the sculptural girl in Ghana next to the section of tree trunks wrenching like attenuated muscles. Our concept of a

physical, atomic world has evolved, but our mythological world has been created.

In photography, discovery and recognition together constitute a special form of creation, for something is brought into the consciousness that was not there before. In the case of the *North Wall*, it is an emotional quality understandable only through experience, entirely beyond rationalization and not definable. It can, however, be discussed, but only by reference to other, already sensitized areas of awareness.

I do not see in this photograph anything that actually makes me afraid. But it is certainly an image that incorporates edges, points and other hazards, and disposes them in such aggressions as to have all the characteristics of an *action* that in actuality would be first difficult, then disturbing and finally terrifying. It is not any of the specific details in the picture, repellent as they are, that induce this terror, but the realization of long-standing fear within, now surfacing in recall, primordial experience with pain, night and the generally impossible, the non-rational. While I am not "afraid" of the photograph itself, I recognize it as a schema of fears far removed from reality to which I, with all mankind, am vulnerable. These fears are qualitative.

Rudolf Otto presents religion as non-rational in that it deals with a quality of mental attitude that is applicable through countless diverse examples. Salvation, as from anything threatening and beyond understanding, is in the nature of a miracle; and the conventional theory of the Miraculous is that it is a variation from what is naturally anticipated, a variation brought about by a Supreme Being. But this is a rational explanation, for orthodoxy cannot deal with the non-rational by dogma and doctrine. In Otto's view, Orthodox Christianity, by not recognizing the non-rational and by insisting on a clarity of concept, has given a "one-sidedly intellectualistic and rationalistic interpretation" to the idea of a Supreme Being, whereas the idea of the Holy and the idea of the Beautiful are both far removed, as mysteries, from the rational. When both the rational and the moral judgments are eliminated, there remains an ethically neutral response, the Numinous. The *North Wall*, then, is initially terrible in its threat of destruction; but, as its miracle unfolds, it becomes beautiful. Both responses are qualitative, and both are expressed in *Awe* that has its origin in fear, in the consciousness of being a Creature before, and in contrast to a *Mysterium Tremendum*.

Carl Jung, writing more anthropologically, covers this point well. Primitive man, he says, was often much more afraid of an "inner

reality"—the world of dreams, ancestral spirits, demons, magicians and witches—than of an external reality. We, his descendants, Jung continues, make rationalistic attempts to dispel this psychic reality, but without complete success, for these natural instincts are strong and can be influenced only by spiritual, rather than rational means, namely a specific energy of the will, not controllable, but seemingly drawn out of the individual by these numinous images.

Every photograph, even the most commonplace, is a search for or an establishment of Being that may be thought of as identity, one-ness, value, even salvation, taking place in the act of focus and the moment of exposure. But to develop through a stage of becoming into Being requires enormous power, an unapproachable dominant authority that Otto terms *Majesty*. Mysticism begins with a feeling of insignificance of self before a manifested majesty, but it develops through transcendence a need for union with that authority. There can be no magic without Majesty. A mystic, sensing the presence of God, will feel that God is more real than he is. An integrated photograph may have more Being than the fragmented photographer who made it.

With its Awefulness and its Majesty, the *North Wall* is surely also Passionate to a shocking degree and in this way like the idea of the Holy. This passion, aroused by the energy of the image, is of the utmost *Urgency*, vital, driving through the moment with a wrathful temper, with will, excitement and an impetus unaccounted for by anything rational, but certainly fired by the teasing polarity of an aggressor's anger and a victim's cowering helplessness. In the field work already referred to, what I sought and often found was the image of electricity. "Love," says a mystic not identified in my text, is "nothing else than quenched wrath," and Jung's libido or psychic life-force is an energy value applied to any activity whatsoever.

Even as a photograph is a search for Being, that attempt not infrequently fails, and what is actually photographed is but a kind of matrix from which a reality might be cast, if that were possible. What is in such a photograph is a Nothing, a numinous non-being that can be discussed obliquely but cannot itself be thought. It is a void between thoughtful realizations. Intangible and inconceivable, it is mysterious, not as something merely beyond a capacity of knowledge or information, but as an *Otherness* of a kind and character totally incommensurable with our own thought processes. This non-being, however, is not beyond feeling, a sense of origins and angle of departure from the

comfortably familiar. This void is filled indirectly by a convincing surrogate, not precisely *this* experience but akin to this one and the opposite of the Other. Certain mystics seek nothingness as the only possible ultimate goal. Certain figurative entities are "known" by reference to what they are not. The *Mysterium* begins as a negative, blank wonder, but gradually and transcendentally becomes supramundane, in a position of holiness where worldly "understanding" is immaterial. "If I had a God whom I could understand, I would no longer think of Him as God."

But in this concept, the idea of the Holy turns out to be not entirely religious, even though it is close to the origins of religion. There is a suggestion of eroticism in the notes on passionate urgency, and this inclusion is developed by Rudolf Otto as one of the analogies and associated feelings. For him, the *Erotic* is an idealization of animal reproductive instinct rising from below the rational to a higher level of mind and feeling, a more complex and rarified experience of love, somewhat above the rational. The quality of the *mysterium*, as both aweful and wonderful, reappears in the quality of *Sublimity* as an element of the Holy, a greatness not merely of size, but of degree of emotional exaltation.

There are those who would wish me to look long and earnestly at my reproduction of the *North Wall* and be influenced by it to search out magic in the field, but without dealing in this way with holiness, within or without religion. For me, this would be inadequate. There is a *Fascination* in the quality of this non-rational mystery that draws me to some form of participation, that keeps me in pursuit of some fulfillment. My search for magic seems a superficial device, and I must find a way to relate my original motivation to human terror of insecurity and abandonment, crying for salvation.

They speak of this increasing, sometimes ascetic compulsion to *possess* the magic power, the perfection, the certainty, at first in what Otto calls the need "simply to appropriate the prodigious force of the numen for the natural ends of man." But as things developed in religion, such a contact was thought of as an end in itself, a good, even a way of salvation, quite different from the more profane aims of magic, and it eventually became the noblest and thus indescribable beatitude.

We need a means of participating in the landscape, and in a personal sense it is of a higher order to bow before the mystical intangibles than to master the scientific facts.

ROBERT ADAMS has published several books of his photographs, including *The New West* (1974), *Prairie* (1978), *From the Missouri West* (1980) and *Los Angeles Summer* (1986). In both 1973 and 1978, Adams received a National Endowment for the Arts Fellowship in photography. He was also rewarded with two Guggenheim Fellowships—one in 1973 and another in 1980—and the 1979 Colorado Governor's Award for the Arts. His photographs have been exhibited and collected internationally. Adams received his Ph.D. in English from the University of Southern California in 1965 and has contributed numerous articles, reviews and introductions to photographic literature. He is also author of the book *Beauty in Photography: Essays in Defense of Traditional Values* (1981).

AMY CONGER received her master's degree in art history from the University of Iowa in 1966 and her Ph.D. in the art history of prints and photographs from the University of New Mexico in 1982. She wrote her dissertation on the first half of Weston's career. She has since written *Edward Weston in Mexico: 1923-1926* (1983) and has coedited *Edward Weston Omnibus* (1984) with Beaumont Newhall. She has also produced a series of essays on Weston and on Latin American photography. Conger is currently a visiting lecturer in the Department of Art History at the University of California, Riverside, as well as a visiting scholar at the Center for Creative Photography at University of Arizona, Tucson, where she is writing a biography on Weston and cataloging all his photographs through a National Endowment for the Arts Grant.

ANDY GRUNDBERG is a photography critic for the *New York Times* and a contributing editor for *Modern Photography*. He first wrote about Edward Weston in 1974 in the essay "Edward Weston, Rethought," published in *Art in America* and reprinted in the anthology *The Camera Viewed* (1979). In 1985 Grundberg won the Reva and David Logan Award for new writing on photography from the Photographic Resource Center in Boston. He serves on the board of directors and is secretary for the Society for Photographic Education; he recently served as curator for an exhibition titled *Painted Pictures*, which was part of the 1986 Houston Foto Fest.

THERESE THAU HEYMAN has been the senior curator of prints and photographs at The Oakland Museum of Art in Oakland, California, since 1972. She received her master's degree in art history from Yale University and has been a visiting history of photography professor at Mills College, as well as a panel member for the National Endowment for the Arts grants in photography. Heyman wrote the introduction for *An American Exodus* (1969), authored *Celebrating Collections: The Work of Dorothea Lange* (1978) and *New California Views* (1979) and contributed an essay to *The Era of Exploration: The Rise of Landscape Photography in the West* (1975). She recently organized and wrote the catalogue for the exhibition *Pioneer Photography of the Great Basin* (1984).

ESTELLE JUSSIM is the author of *Visual Communication and the Graphic Arts* (1974); *Slave to Beauty* (1982), the biography of F. Day Holland, and *Frederic Remington, the Camera, and the Old West* (1983). She is coauthor with Elizabeth Lindquist-Cock of *Landscape as Photograph* (1984). Her essay "Propaganda and Persuasion", based on research for *Landscape as Photograph*, appeared in The Friends' 1984 publication, *Observations: Essays on Documentary Photography*. She is also a critic for the *Boston Review*. In 1982 Jussim received a Guggenheim Fellowship to pursue research on the career of Alvin Langdon Coburn. She teaches the history of photography, film, graphic arts, visual communication and communication theory at Simmons College in Boston.

ALAN TRACHTENBERG teaches American studies and English at Yale University, where he is chairman of the American Studies Program. Among his many books are *Brooklyn Bridge: Fact and Symbol* (1965), *The American Image: Photographs from the National Archives, 1860-1960* (1979), *America and Lewis Hine* (1977) and *Incorporation of America: Culture and Society in the Gilded Age* (1982). He also edited a collection of writings, *Classic Essays on Photography* (1980), and contributed the essay "Walker Evans' America: A Documentary Invention" to The Friends' 1984 publication, *Observations: Essays on Documentary Photography*. Trachtenberg, a recipient of a 1983 Rockefeller Fellowship, is presently completing a book on photography and history in America.

PAUL VANDERBILT was born in 1905 and educated at Harvard University. He has devoted his life to extending the principal function of research libraries beyond the field of printed books to include works of art, motion pictures and especially photographs. He has held positions at both the Philadelphia Museum of Art and the Library of Congress and is presently curator emeritus of the Iconographic Collection at the State Historical Society of Wisconsin. Vanderbilt lives in Madison, Wisconsin, where he is engaged in writing and lecturing.

MIKE WEAVER is Reader in American Literature at Oxford University, England. He has been a prolific writer on photography, having authored the books *William Carlos Williams* (1971), *Julia Margaret Cameron 1815-1879* (1984) and *The Photographic Art: Pictorial Traditions in Britain and America* (1986). During 1986 his monograph on Alvin Langdon Coburn will be published by Aperture Books, and his second book on Cameron, a study of her Overstone Albums, will be released by the Getty Museum in September.

CHARIS WILSON was born in San Francisco in 1914 and met Edward Weston twenty years later in Carmel Highlands, where she grew up. Wilson was married to Weston until 1946 and served as his ghostwriter for all the major photographic articles published by him after 1934. Together they produced two books of photography, *California and the West* (1940) and *Cats of Wildcat Hill* (1947). Wilson has written the introduction for the new edition of *California and the West* (1978), as well as the text for *Edward Weston Nudes* (1977). She has also created video tapes on Edward Weston for the Huntington Library in San Marino and the University of California at Santa Cruz, where she has organized exhibitions of his prints. Wilson is currently working on a memoir of her years with Edward Weston.

PETER C. BUNNELL is McAlpin Professor of the History of Photography and Modern Art at Princeton University and serves as the president of the Board of Trustees of The Friends of Photography. He has edited two recent anthologies of writings on photography, *A Photographic Vision, Pictorial Photography 1880–1923* (1980), and *Edward Weston on Photography* (1983). Bunnell is presently editing Minor White's journals for publication and is producing a major retrospective exhibition of White's photographs.

DAVID FEATHERSTONE is executive associate of The Friends of Photography and has been on the staff of the organization since 1977. He contributed the introduction to *Photographs of Mother Teresa's Missions of Charity in Calcutta*, by Mary Ellen Mark (Untitled 39), and served as editor for *Observations, Essays on Documentary Photography* (Untitled 36). He is also the author of the monograph *Doris Ulmann: American Portraits* (1985).

The Friends of Photography, founded in 1967, is a not-for-profit membership organization with headquarters in Carmel, California. The programs of The Friends in publications, grants and awards to photographers, exhibitions, workshops and lectures are guided by a commitment to photography as a fine art, and to the discussion of photographic ideas through critical inquiry. The publications of The Friends, the primary benefit received by members of the organization, emphasize contemporary photography yet are also concerned with the criticism and history of the medium. They include a monthly newsletter, the periodic journal *Untitled* and major photographic monographs. Membership is open to everyone. To receive an informational membership brochure, write to the Membership Coordinator, The Friends of Photography, Post Office Box 500, Carmel, California 93921.

The
Friends
of
Photography

Design by Desne Border. Photocomposition in Bembo by Mackenzie-Harris Corp. in San Francisco. Laser-scanned Fultones® printed by Gardner / Fulmer Lithograph in Buena Park, California. Bindery by Graphic Arts Center in Portland, Oregon.